liith h.

Da

CW00822071

OXFORD
PUBS

DAVE RICHARDSON

AMBERLEY

First published 2015

Amberley Publishing
The Hill, Stroud
Gloucestershire, GL5 4EP

www.amberley-books.com

Copyright © Dave Richardson, 2015
Maps contain Ornance Survey data.
Crown Copyright and database right, 2015

The right of Dave Richardson to be identified
as the Author of this work has been asserted in
accordance with the Copyrights, Designs and
Patents Act 1988.

ISBN 978 1 4456 4728 9 (print)
ISBN 978 1 4456 4729 6 (ebook)

British Library Cataloguing in Publication Data.
A catalogue record for this book is available from
the British Library.

Typesetting by Amberley Publishing.
Printed in the UK.

Contents

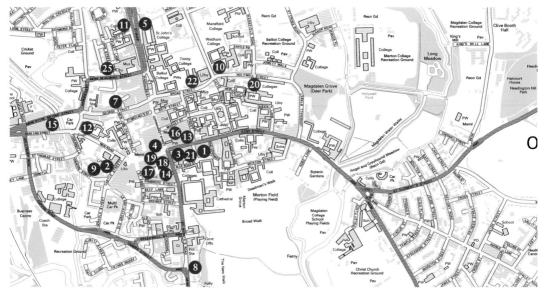

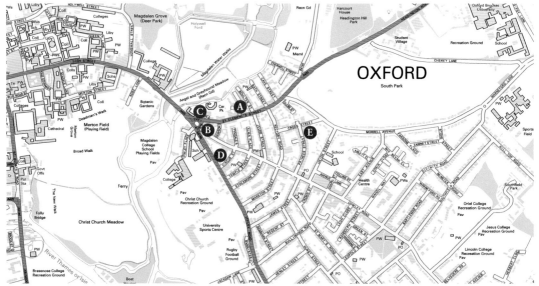

MAP 1 – CITY CENTRE

1. Bear Inn
2. Castle Tavern
3. Chequers
4. Crown
5. Eagle and Child
6. Golden Cross
7. Grapes
8. Head of the River
9. Jolly Farmers
10. King's Arms
11. Lamb and Flag
12. Lighthouse
13. Mitre
14. Old Tom
15. Oxford Retreat
16. Roebuck (Wagamama)
17. Royal Blenheim
18. St Aldate's Tavern
19. Swindlestock Tavern
20. Turf Tavern
21. Wheatsheaf
22. White Horse
23. White Rabbit

A Angel and Greyhound
B Cape of Good Hope
C Half Moon
D Mad Hatter
E Port Mahon

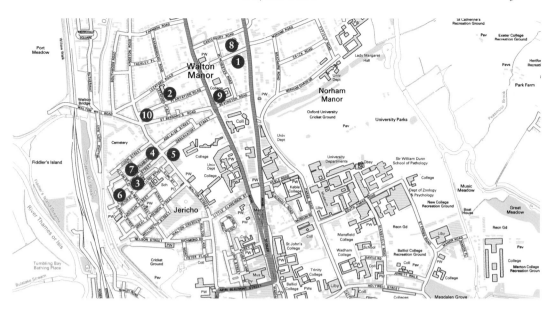

MAP 2 – JERICHO/NORTH OXFORD

1. Gardeners Arms, North Parade
2. Gardeners Arms, Plantation Road
3. Harcourt Arms
4. Jericho Tavern
5. Jude the Obscure
6. Old Bookbinders
7. Rickety Press
8. Rose & Crown
9. Royal Oak
10. Victoria

Introduction

Oxford is renowned all over the world as a seat of learning but also offers, to quote one of its most famous pubs, 'An Education in Intoxication'. Its most historic pubs are known by countless thousands of visitors, students, ex-students and residents, but the appeal of Oxford's pubs goes much further. The city is a melting pot for all kinds of people and that is reflected in its hostelries.

Did you know, for example, about the witch's broomstick plastered up in a pub for fear it would unleash a curse? Have you seen the classic painting on a pub ceiling where God and Adam toast each other with glasses of beer? Did you know about the famous rock band that first played in an Oxford pub, the infamous brothel keeper, or the many literary connections from *The Hobbit* to modern day poets?

Oxford pubs might have many claims to fame, but *Inspector Morse* is undoubtedly the main draw for many with pubs featuring high on the list of classic Oxford scenes used in the long-running ITV series, continuing with *Lewis* and the prequel *Endeavour*. Many pubs claim a connection with Morse, but one entices customers in with the claim it's the only pub he didn't drink in – and shame on him!

As throughout Britain, Oxford's pubs are continuing to go through a period of great upheaval – meaning those that survive relatively unchanged really are a cause for celebration. There have been a few closures on the edge of the city centre, but the number of drinking establishments has increased in recent years as more modern bars have opened up. In Oxford's suburbs, however, the rate of closures is increasing as pubs are converted into houses, restaurants, supermarkets, guest-houses and even, in one case, an Islamic study centre. Many pubs have changed their names, sometimes at least twice, but here you can follow their stories.

If you care about traditional pubs then do join the Campaign for Real Ale (CAMRA), one of Britain's most successful pressure groups with over 170,000 members, which is fighting hard to save pubs having won the battle for real ale. It also supports independent breweries, which are growing rapidly throughout Britain, though not yet in Oxford itself. But the city that was once home to the historic Morrell's and Halls breweries hopes to welcome more craft breweries soon.

There are some ninety traditional pubs within the Oxford Ring Road, and in this book you will find descriptions of over forty of them chosen on the basis of their historic interest. About half these pubs are in the centre, plus others nearby grouped together for easy walking tours. Finally, there's a selection of pubs around the city including some famous riverside venues. Featured on the front cover are The Head of the River (top) and The Mitre (bottom).

Enjoy your Education in Intoxication!

Dave Richardson, April 2015

Acknowledgements

First I must pay tribute to my two illustrious predecessors: *An Encyclopaedia of Oxford Pubs, Inns and Taverns* by Derek Honey (The Oakwood Press, 1998); and *Oxford Pubs Past and Present* by Paul J. Marriott (Paul J. Marriott, 1978) – both highly recommended for delving back through the centuries. *The Oxford, Witney & Abingdon Pub Guide*, edited by Matt Bullock (CAMRA, 2011) is a useful listing of every drinking establishment within the area. Of great interest to anyone focusing on history is *The Encyclopaedia of Oxford*, edited by Christopher and Edward Hibbert (Macmillan London, 1988). *The Oxford of Inspector Morse*, by Bill Leonard (Location Guides, 2006) is one of several books looking at where the TV series, based on Colin Dexter's novels, was filmed. Online resources have also been consulted, the most useful being the Oxford History website by Stephanie Jenkins (www.oxfordhistory.org.uk). Thanks also to author Stanley Jenkins, and poet Tom White.

Most of the interior photographs in this book, and some external ones, are by Phil Gammon, an experienced professional photographer with a growing reputation for pub portraits (www.philgammon.co.uk). Most of the historic photographs are courtesy of the Oxford Mail/The Oxford Times (Newsquest Oxfordshire Ltd), and I would like to personally thank its librarian Chris McDowell for all his support – the library, open by appointment, is a great resource for the people of Oxfordshire. Some of the older photographs in this archive are by unknown persons. Most other photographs are by the author, except where shown.

Finally I would like to thank my friends at the Oxford branch of CAMRA, where I edit *The Oxford Drinker* magazine, and especially branch Chairman Tony Goulding for all his enthusiasm. Thanks to all the landlords who took the time to talk about their pubs, and especially to Andrew and Debbie Hall at the Rose & Crown, Jacqueline Paphitis at the White Horse, Helen Hazlewood at the General Eliott, Richard and Kathryn Gibson at the Angel and Greyhound, and Ez Parkin at St Aldate's Tavern, for going the extra mile. Finally, thanks to my wife Victoria for her love and support, and for occasionally acting as chauffeuse.

Part I

The City Centre

Oxford's city centre has about thirty pubs, and over twenty are described here including three which have long since vanished. The centre is compact, and it takes only ten to fifteen minutes to walk between any of the pubs on the map.

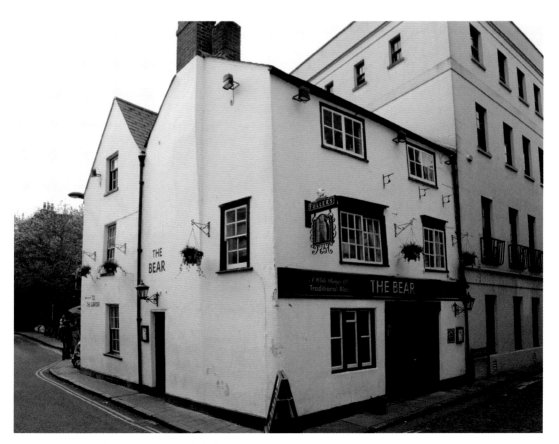

Bear Inn (*Photo courtesy of Phil Gammon*).

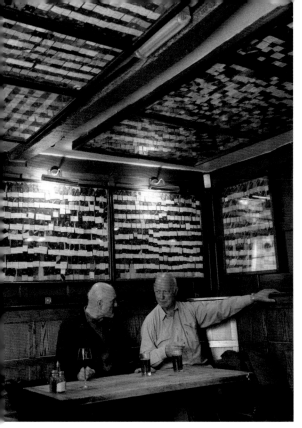

Left: The ties that bind at the Bear Inn (*Photo courtesy of Phil Gammon*).

Below: Richard Burton and Elizabeth Taylor at the Bear Inn in 1963 (Photo Courtesy of Oxford Mail/The Oxford Times).

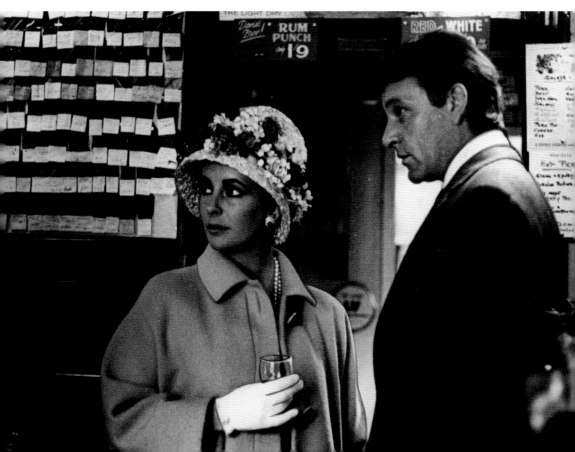

Bear Inn, Alfred Street

This is one of the most characterful pubs in a city with more than its fair share of history and tradition, and it also claims to be the oldest although the Mitre, on High Street, has a more persuasive claim to that title. Alfred Street is a narrow lane at right angles to the 'High' and the original Bear Inn once ran along the whole length of it, being known as Parne Hall and Le Tabard in the fourteenth century before becoming the Bear in 1432. It was one of Oxford's largest and most important hostelries during the 1500s, with notable guests including visiting judges. One major incident recorded here was in 1586, when Lord Norris was attacked by students from Magdalen College angry that some of their number had been imprisoned for poaching deer in the royal forest of Shotover, just outside Oxford. By the eighteenth century it was a major coaching inn, and by the time the old Bear Inn closed in 1801 it could stable up to thirty horses.

The building we see today was originally behind the old inn and dates from 1606, being an ostlers' house for the men who looked after the horses. It was first recorded as an inn called the Jolly Trooper in 1774, taking the name Bear Inn in 1801 when the original building was demolished. Although this pub name sometimes relates to the cruel practice of bear baiting, a popular entertainment for hundreds of years, the name of this pub relates to the fifteenth-century Earl of Warwick, Richard Neville, whose symbol is a bear and ragged staff.

The Bear's main and possibly unique claim to fame is its collection of more than 4,000 ties which have been pinned in cabinets on the walls and even the ceiling. The collection was started in 1954 by landlord and *Oxford Mail* cartoonist Alan Course, who started snipping the bottom off ties worn by his customers. Many of them are grouped into themes, with one display case being full of ties associated with hockey clubs, for example. Although the tradition does continue, with people sometimes coming into the Bear offering their ties, the pub has simply run out of space to display any more.

It retains its original layout with three small rooms, low ceilings that challenge the tall, a wooden floor and roaring coal fire in winter. This is still every inch a traditional pub, with no music, TV or slot machines, which has been held dear by generations of students with Christ Church, Oriel, Merton and Corpus Christi colleges all very close. It is now run by Fuller's brewery of London, but its regular guest ale is, appropriately, Scholar by Shotover Brewery from near Oxford. It is still a very small pub despite having a heated patio area outside, and apt to get very busy particularly in term time.

A procession of celebrities, with or without ties, has come to the Bear through the ages. Among the most notable were actors Richard Burton and Elizabeth Taylor in 1963, after Burton had visited his friend Neville Coghill, professor of English literature at Merton college. Rock singer Ian Gillan, long associated with Deep Purple, is said to have agreed to join Black Sabbath after an all-day session at the Bear in 1983. The pub appears in a single episode of Inspector Morse, *Absolute Conviction*, when Morse chases escaped prisoner Charlie Bennett through the bar.

A poem written in 1990 by the then landlord, Mick Rusling, is framed on the wall and gives some idea of the mutual affection for the Bear held by customers and staff. Entitled 'Ode to the Followers of the Bear', it includes the lines:

To May morn masses in their hordes
Still drunk from May morn Eve
Who'd drink all day, 'til closing time
And still refuse to leave
To Christ Church boys for what you were
So very good to me
And Oriel boys, what can I say?
You're something else to see

Castle Tavern, Paradise Street

One of Oxford's leading gay pubs, the Castle Tavern is a handsome Victorian building completed around 1890 which stands on the site of tenement dwellings dating from the late eighteenth century. A curiosity about Castle Street (the tavern is on the corner with Paradise Street) is that it was re-aligned when the adjacent Westgate Centre was built in 1970–72, and is now several feet below the original street level. The raised position of the tavern is clear evidence of this and a flight of steps now leads up to the entrance.

Oxford Castle is now a bustling leisure hub with a museum and visitor centre, bars, restaurants and a five-star Malmaison hotel, but if you came here ten years ago there

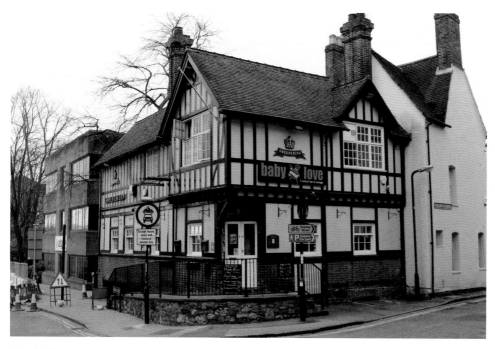

Castle Tavern.

would have been nothing to see as all this has been developed recently with the complex officially opening in 2006. The castle dates from 1071 but only the mound (alongside New Road) and two towers remain, with the remainder of the site occupied by a prison for hundreds of years, not closing until 1996. The Malmaison hotel occupies some of the prison buildings, and has retained the long corridors and metal staircases for the delight of its guests with one guest room created out of three cells. The prison structure can be clearly seen, especially when entering the complex beside the modern Swan and Castle pub.

The Castle Tavern changed names to the Paradise House in the 1980s and then the Culture Vulture, before reverting to the original. It is also branded as Baby Love, the name of a now closed bar under the same management. It specialises in cocktails and has a large basement room (complete with dancing pole) where discos are held at weekends.

Chequers, High Street

If you walk down High Street today you will see only one pub, the Mitre. But close to the Carfax end of the street you will see the sign for another, and a stroll down the alleyway (between a jeweller and a chocolate retailer) will be rewarded by a visit to

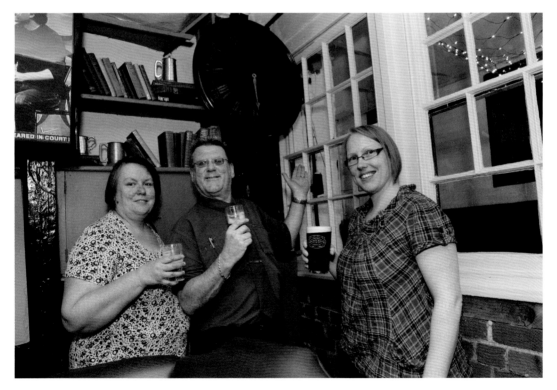

Time gentleman, and ladies, please! Posing by the Chequers' eighteenth century clock are Oxford CAMRA members Marie and Alan Oliver, with manageress Kerry Skrzypiec (right) (*Photo courtesy of Phil Gammon*).

Entrance to the Chequers (*Photo courtesy of Phil Gammon*).

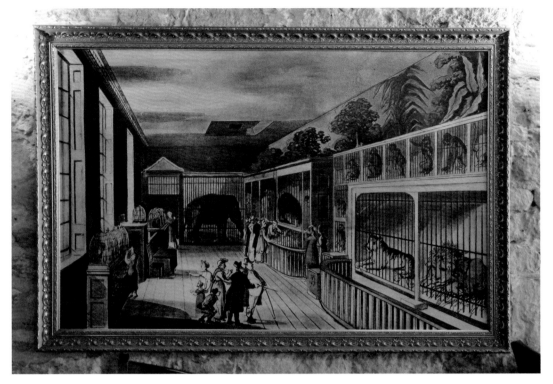

Painting at the Chequers depicting its time as a zoo (*Photo courtesy of Phil Gammon*).

one of Oxford's most interesting pubs, the Chequers. Tenement houses were built here as early as 1260 and a tavern was operating in 1500 although the name Chequers was not recorded until 1605.

This is a common name for pubs, and various theories about its origins include references to the board game of chequers, or draughts, which was commonly played in pubs. A chequers board was often used by tax collectors when going about their work, but the most plausible explanation for the name of this pub is that a moneylender traded here in the fifteenth century just before the pub was built, and a chequers board has denoted a moneylender since Roman times.

You still get the impression you are entering an ancient place, as the pub has a rambling courtyard and beer garden. It is not just people but also an array of exotic animals that have come down this alleyway, as a sign outside the pub informs us. In 1757 a camel from Cairo was exhibited here, and by 1762 it was operating as a mini-zoo with fourteen large animals including a sea-lion and a shark. A painting on the wall of the dining room recalls the scene. Human exhibits included Siamese twins in 1758 and a giant from Hertfordshire in 1776, who 'caused such interest that he spent most of his time dining in various colleges'.

An unsubstantiated story recorded on the plaque outside the pub mentions a group of monks who, during dissolution of the monasteries by Henry VIII, were driven into an underground passage running from the Chequers under the High, where they

were sealed up and left to die. It has been said that, 'When the pub is very quiet, the screams of those dying monks can still be heard, so it is alleged. No-one has ever found a tunnel, let alone the bones of dead monks beneath High Street.' But the rear of the pub was once occupied by monks, and a fifteenth-century altar screen adorns the dining room.

Whether you believe the story or not – and there are numerous passages and cellars under the old city – a visit to the Chequers is a fascinating experience. It is run by the Nicholson's pub chain which appreciates and celebrates the history of its premises, and this pub is on three levels with the original bar at ground level, the Monks Bar just above and a dining room on the third level complete with quirky features such as a stuffed magpie exhorting you to make a wish. Other historic features include an English Tavern Clock made in 1760.

Crown, Cornmarket Street

There used to be many inns and hotels on one of Oxford's two main shopping streets, but now there is only one and it is one of the oldest. Hidden away in a courtyard beside McDonald's, it is still a haven of tranquility and a good place to rest and consider its associations with the world's greatest playwright.

The Crown Inn, to give it its full name, is sometimes confused with the Crown Tavern which stood on the opposite side of Cornmarket Street and disappeared in 1750. At some point the Crown Tavern was combined with another pub on this site called the Salutation Inn, a meeting place for Roman Catholics. The Crown Inn stands

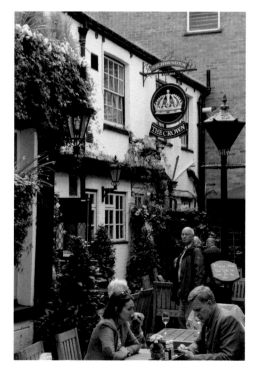

The Crown (*Photo courtesy of Phil Gammon*).

on the site of a private house dating back to the eleventh century, being recorded as Spicer's Inn in 1364 and the King's Head in 1495, first being known as the Crown in 1600 when it passed into royal hands. Like the Chequers, the Crown Inn used to exhibit exotic animals including a cassowary (a giant flightless bird, recently discovered) in 1779.

The Crown was once a rambling coaching inn and until 1774 it had a direct frontage onto Cornmarket Street, and the present building was the stables and outhouses. The renowned Oxford diarist Anthony Wood (1632–1695) was a regular, recording a visit to London by stagecoach in 1667 which took no less than three days. In general the journey took two days, depending on the weather and the season. Departures were at 4.00 a.m., passengers staying overnight at Beaconsfield in Buckinghamshire before reaching the capital at 4.00 p.m. the following day. Within two years, however, road improvements made the journey possible in only one day by 'flying coach'. Oxford was one of the busiest places in England for stagecoaches by the early nineteenth century and stagecoaches visiting Oxford often had exotic names, one being the Pig and Whistle which features in the book *Tom Brown's School Days*.

Many visitors ask what connection Shakespeare might have had with Oxford, as the city was long established as a primary seat of learning by his time and would have been an obvious place to stop on the long journey between London and his birthplace, Stratford-upon-Avon. He is thought to have visited frequently and was a friend of John Davenant (Lord Mayor of Oxford when he died in 1622) who kept the Crown Tavern across the road, staying here or at the Crown Inn. A plaque outside the Crown Inn mentions that Shakespeare 'is said to have been more than friendly to John's wife', and that Shakespeare was in fact the father of John's son, William. He was certainly William's godfather, and the theory was encouraged by William's literary success, becoming Poet Laureate in 1638.

The Crown Inn is run by Nicholson's on thoroughly traditional lines. It once had a series of small rooms, but in the long, narrow open plan style of today it is still possible to have a quiet drink or meal and think of its long history.

Eagle and Child, St Giles

There can be few pubs that attract people from all over the world just to see them, but that is a distinction claimed by this fine old literary pub on St Giles. Such is the global fame of the *Hobbit*, *Lord of the Rings* and *Chronicles of Narnia* films that many thousands of fans want to discover the men who wrote the books that inspired the films, and this is where they drank.

Hobbit and *Lord of the Rings* author J. R. R. Tolkien (1892–1973) was one of an informal group of writers who met here regularly, and christened themselves The Inklings. Other members of the group included C. S. Lewis (1898–1963), author of *The Chronicles of Narnia*.

Lewis appears to have been the de facto head of The Inklings, who called the pub the Bird and Baby. He met Tolkien when both were in senior academic posts in the English department of Oxford University. A plaque in the room immediately behind

the bar tells of their meeting at this spot every Tuesday morning from 1939 to 1962. 'The conversations that have taken place here profoundly influenced the development of twentieth-century English literature,' it notes. Also framed is a 1948 declaration by Lewis, Tolkien and others that the undersigned 'have drunk your health', which was presumably presented to the publican.

The pub gets its name not from an imaginary twosome in either man's works but, more prosaically, from the crest of the Earls of Derby. It was first recorded as an inn in 1650, gaining the name it has had ever since in 1684. Although it has been greatly extended, some of the ancient layout remains as it is a narrow pub, with cosy alcoves either side of the entrance, one of which was known as the Rabbit Room, apparently because the landlady kept rabbits there. Her name was Florence Blagrove and she was at this pub for over forty years.

Beyond the room where The Inklings met are the modern extensions, including a conservatory at the very back, with art prints. The pub was last extended in 1987, but not before a hearty exchange of views between the brewery which owned it, Halls Oxford and West (owned by the giant Ind Coope), and the Tolkien Society. The intention was to restore some of the character lost in a revamp of 1959, including what the *Oxford Mail* described as 'the now despised flock wallpaper style of the 1950s'.

But the society was disturbed that its character would in fact be lost. The revamp happened after a long-serving landlady, Win Reading, was told to move on, as the brewery wanted to install a manager although she had won the regional heat in the Babycham Pub of the Year contest. She described it as the last traditional, tenanted pub in the city, though this may have been an exaggeration.

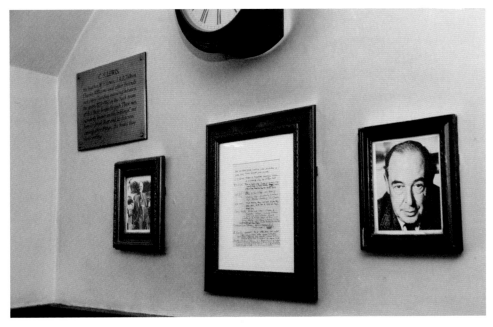

The Inklings bar at the Eagle and Child (*Photo courtesy of Phil Gammon*).

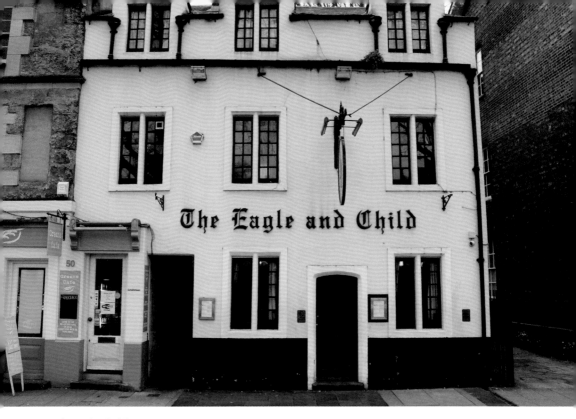

Eagle and Child.

The Tolkien Society wrote to the brewery saying people all over the world could probably name only one Oxford pub, the Eagle and Child. It cautioned against a kitschy revamp to create a Tolkien Room or Inklings Lounge, but nor did it want 'an anonymous watering hole'. Its fears were, however, unfounded. Despite the extension, the front part of the pub retains great character and probably satisfies most Tolkien and C.S. Lewis devotees – although what they would make of the dreary piped music is open to question. But another revamp is planned in a few years, as the present layout with only one small bar leads to overcrowding.

The spirit of these writers lives on, and what a lively spirit it is. The re-opening in 1987 was attended by Father William Hooper, Lewis's secretary in 1963 and his literary executor. He recalled that Lewis was 'a man of robust thirst' who never drank halves, and the conversation of The Inklings was often so lively that other drinkers would stop talking and listen. Hooper approved of the revamp. 'My first thought was that this was *our* pub again,' he said. Let's hope it remains so.

Golden Cross, Cornmarket Street

You can no longer simply go for a drink at the Golden Cross, and the vast majority of diners at the Pizza Express restaurant would never know that this was once, probably, the city's oldest inn. This Grade II listed building, by a passage leading to the Covered Market, bears the two dates 1193 and 1988 (when it was last renovated as part of an expanded Golden Cross Shopping Centre), and still has

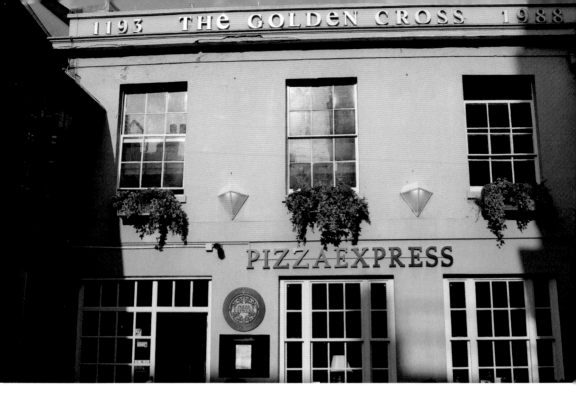

The former Golden Cross Inn, now Pizza Express.

some wall paintings dating from the sixteenth century which were discovered in 1949 and are now protected by glass casing. An inn was first recorded here in 1193 when Osney Abbey gave a licence to a man called Mauger, when it was known as Mauger's Hall; later, it became the Cross Inn. By the late fourteenth century it belonged to Sir Robert Tresilian, a lawyer and judge who tried many people after the Peasants' Revolt in 1381, sending more than thirty for execution, before he himself was charged with treason and executed at Tyburn in London, in 1388. The earliest parts of the present building date from the fifteenth century, and it adopted the name Golden Cross in 1764.

For hundreds of years it was one of the most prestigious places to stay in Oxford, hosting exhibitions and even staging plays as the diarist Anthony Wood noted in 1658. Like many ancient inns, the Golden Cross was very large and included shops and living accommodation as well as places to eat and drink. An inventory in 1697 lists rooms with intriguing names such as Angel, Maiden Head and Dovehouse. Whether a real golden cross ever stood outside the building is a matter of debate, although in 1269 a golden cross was put up by Oxford's Jews as punishment for having broken a wooden cross during a religious procession.

The Golden Cross Shopping Centre is reached through an archway on Cornmarket Street which leads on into the market, with old buildings straight ahead (the inn) and also to the left and right, dating from the fifteenth and seventeenth centuries respectively. Bearing in mind the many uses put to rooms in the original, very large inn, today's eclectic mix of small shops and restaurants is perhaps appropriate.

Grapes, George Street

Surrounded by contemporary theme bars and restaurants in Oxford's main nightlife quarter, the Grapes is a rare survivor as a traditional pub in a street where once there were many. Considered to be one of the oldest surviving buildings on George Street, it dates from about 1820 and was rebuilt in the 1870s. It takes its name (which was originally Bunch of Grapes) from the type of pub that sold wine in addition to beer, which was often not the case at a time when many pubs were basic beer houses. Other pubs in George Street during the 1880s are long gone, including the Anchor, Oddfellows and Punch Bowl.

Until 1973 the entrance was down a corridor, and it was once one of several Oxford pubs (another was the Gloucester Arms, now called the White Rabbit) with swinging front doors likened to a Wild West saloon. A sympathetic restoration by new leaseholder Bath Ales, in 2012, revealed original Victorian features and tiling, while sweeping away the rather gloomy atmosphere. Partitions between some of the seating give it an intimate feel. It remains popular with patrons of the New Theatre directly opposite, as those who leave their seats promptly at the interval may get served more quickly at the Grapes than if they queued for more expensive drinks at the theatre's bars. The theatre posters that once graced the walls are no more, however.

This is the only pub outside the West Country run by Bath Ales, which has won many plaudits for its beers, some of which have the word Hare in their names. It holds regular beer festivals and promotes craft keg as well as cask ales. With competitors on George Street including the O'Neill's and Wetherspoon chains, it is a haven of tradition on one of Oxford's busiest streets.

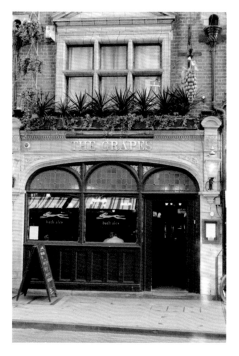

The Grapes.

Head of the River, Folly Bridge

Although it has only been a pub since 1977, this imposing building at the north end of Folly Bridge has a long history as a warehouse in the days when Oxford had a substantial river trade. A warehouse stood on this site in the eighteenth century, becoming known as the Wharf House by 1827, and a crane from this period is retained on the large riverside patio. The outside seating makes this a very popular venue in summer.

The building later became a repair centre for a boatyard owned by Salter Brothers, a grand old Oxford name established in 1858 which continues in business to this day on the opposite side of the river. Salter's Steamers operates twice daily return trips to Abingdon during the summer and also hires out boats and punts. It has a long history of boat building, and runs cruises from several other locations along the Thames including Reading and Windsor.

River traffic in Oxford declined with the coming of the railways in the 1840s, although it had already started to drop when canals were constructed in the previous century. Folly Bridge was rebuilt in the 1820s to make navigation easier, and at that time there were numerous wharves in the area receiving coal and general goods. Flooding was a regular problem and the river was insufficiently dredged, a situation only rectified by construction of locks around the turn of the nineteenth century, although flooding continues periodically.

While boat building and repair continued to keep the building occupied for many years, by the 1970s it was disused and considered an eyesore that gave a bad first

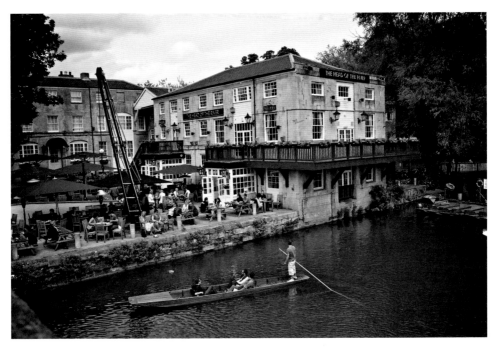

The Head of the River (*Photo Courtesy of Fuller's*).

impression to visitors arriving along Abingdon Road. In those days it was a radical step to turn a disused building into a pub, with many original features retained and the building finished in Headington stone, the material used to build many of the colleges.

It might appear that the pub is indeed at the head of the river, but a glance at the pub sign tells you why it is so-called as it depicts a rowing team. The name was the result of a competition in the *Oxford Mail*, with the winner chosen from 2,700 entries. The Head of the River is the victorious team in the 'bumping races', which started in 1815 when teams used to race to Folly Bridge from Iffley Lock and try to bump into the team in front, with the team at the very front winning the prestigious title. This is not however the official Head of the River Race, held on the Thames in London, as the 'bumping races' are an Oxford institution.

They are the climax to Eights Week, a four-day event held in May each year when teams of eight from various colleges compete for the title. Christ Church and Oriel College (with thirty-three and thirty wins respectively) currently head the winners' table, Brasenose being the first winner in 1815 and Oriel the winner in 2015. Rowing takes place for most of the year between Folly Bridge and Iffley Lock, and can be enjoyed from the towpath leading along the opposite side of the river from the pub.

The pub appears in the 1984 film *Oxford Blues*, a remake of *A Yank at Oxford* from 1938. The Head of the River today is one of the most successful pubs in an empire of 400 plus run by London brewery Fuller's, and it also has guest bedrooms. This is a good place to discover Oxford from the river, with boats and punts available for hire nearby.

Jolly Farmers, Paradise Street

It may not look heavenly today, but Paradise Street is so-called because here stood an orchard owned by the Penitentiary Friars. A couple of hundred yards from the junction with Castle Street is the Jolly Farmers, one of Oxford's two main gay pubs – the other being the Castle Tavern/Baby Love on this corner. The building dates back to at least the seventeenth century and gets its name from a produce market once held near here, and as there was a farrier's shop opposite, the farmers came here for refreshment while their horses were shod.

A pub was first recorded here in 1829, and by 1842 it was known as the Jolly Farmers when owned by Halls Brewery. A walk around the building will soon give the impression that it is considerably older, with low ceilings, exposed beams, nooks and crannies, and an ancient fireplace. The pub is on two levels, with a beer garden.

The *Oxford Mail*'s renowned writer S. P. M. Mais visited in 1957, remarking, 'I found no farmers, jolly or otherwise.' He described it as one of the smallest and most picturesque of Oxford's pubs, so presumably it has been enlarged since then though not extended. He also noticed a 'musician's seat' near the fire, and a niche cut in the stone to rest a violin or other instrument. It also had a powder cupboard for keeping gunpowder dry.

The pub holds many events, and is a major supporter of the Oxford Pride procession.

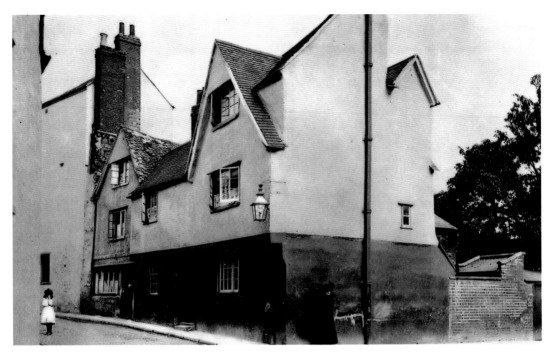

Above: A view of the Jolly Farmers from around 100 years ago.

Below: Jolly Farmers.

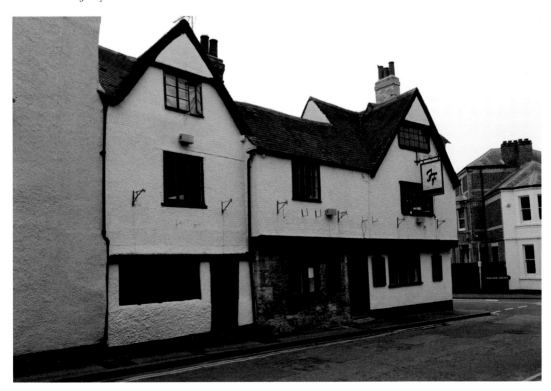

King's Arms, Holywell Street

You can tell that a pub is much loved by its regulars when they contribute not only photographs, but mementoes and even poetry and cartoons for display on its walls. So it is with the King's Arms, one of the oldest and best-known pubs in the city, situated in the heart of the university area and literally surrounded by colleges and other venerable institutions. Among its regulars was the writer John Wain (1925-1994), whose 1953 novel *Hurry on Down* was a major success, and whose handwritten poem 'Thanks for a Hat' is on the wall.

The pub's history has been traced back to 1607, although an inn called the Lion had occupied this site and before that an Augustinian priory. The King's Arms was and is a very common pub name, but in 1607 it was a novelty as pubs wanted to show their allegiance to James I, who reigned from 1603 to 1625, after the long reign of Elizabeth I. James I helped found Wadham College, which had acquired the pub by 1630 and still owns it today with students occupying the upstairs rooms. The façade is eighteenth century.

It is still a large pub but was an even larger inn, with stables and a rear courtyard where plays and prize fighting were popular entertainments. According to one historian the inn had 'a very large backside, for the safe custody of carts, wains and other commodities of guests thither resorting'. The first Oxford performance of *Hamlet* was reportedly here, but less highbrow entertainments including backsword or singlestick prize fighting and 'cudget playing' were notorious. In 1661 local hard man Dennis White fought H. Wordley of Thame 'almost to the death', while an un-named Cornishman laid three Welshmen low before calling out for more opponents from that country.

By the late eighteenth century the King's Arms was a major coaching inn, and used by visitors to the nearby Bodleian Library. The end of coaching meant the courtyard and stables were demolished, but it continued to function as a hotel until 1962. It has always been a meeting place for students, academics and townspeople, and nowadays of course for large numbers of tourists.

The King's Arms didn't always move with the times, and the rear bar or smoke room was designated 'men only' until 1973. This is recalled hilariously in a cartoon on the walls, showing two men at a urinal actually inside a pub, one remarking that this could be the last 'men only' bar in the country! One wonders why … Even in 1998, it was reported, unescorted women were given 'a frosty reception' by some of the academics. Ladies are now welcome alone or not, and lone students of both sexes can often be seen toiling at a laptop as their counterparts in previous centuries toiled with a quill pen.

Photographs adorn the walls throughout, and the Wadham Room (on the left of the main entrance) is more like a library. The large main bar and dining area does not have the character of the bar and rooms at the rear, however, where regulars gather every morning. There are two side rooms plus a small snug (with its own entrance) here, with a real fire in an ancient grate in 'The Office' nearest the street. Browsing the many pictures could take a whole evening or afternoon, and as many of these were of ordinary customers (two ladies in graduation gowns, for example), you wonder what happened to them. There are more cartoons, too, including 'All the Young Dudes' on graduation day.

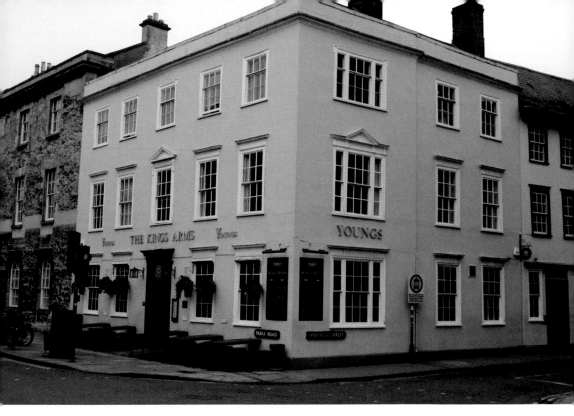

Above: The King's Arms.

Below: 'The Office' at the King's Arms (*Photo courtesy of Phil Gammon*).

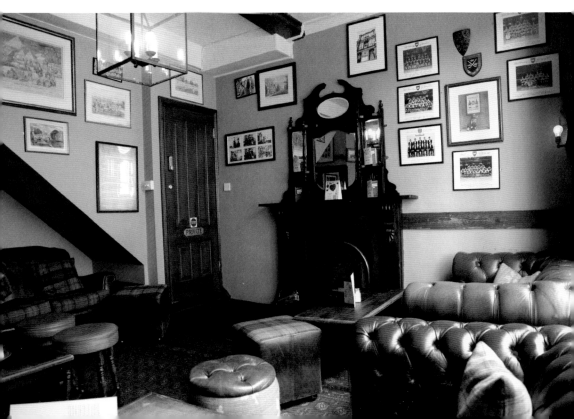

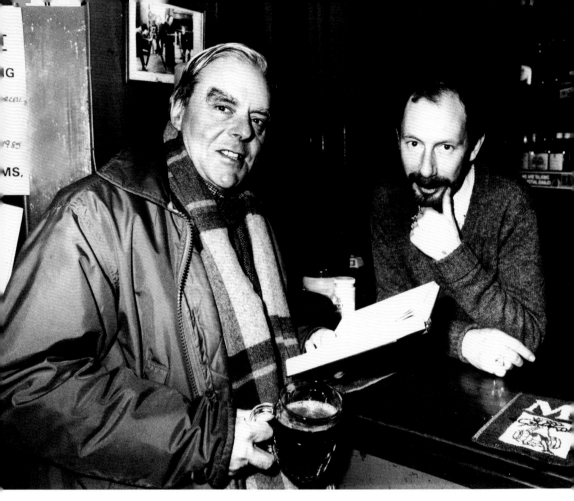

Writer John Wain (left) with King's Arms landlord David Kyffin, in 1985. A handwritten poem by Wain hangs on the wall, with his obituary (*Photo Courtesy of Oxford Mail/ The Oxford Times*).

At least two poems adorn the walls, one by Tom White who extols 'a dozen scotch eggs, to embrace a new republic built on beer's rich light'. And in a rear room, in addition to his obituary, is John Wain's handwritten 'Thanks for a Hat'. This short poem recalls how the hat was stolen from this, his favourite inn but soon found by friends. His double prize was return of the hat and 'the kindness in their eyes'.

Among the pictures are both the Queen Mother and Prince Charles pulling pints, but these were not taken at the pub but possibly at the 'brewery tap' of Young's brewery in London. Young's took over the pub in 1991 although beers of this name are now produced by Charles Wells in Bedford. A large poster-map shows Grenoble in France, as the pub was 'twinned' with a bar in that French city, La Table Ronde, in 1994. Inspector Morse found his way here in *The Secret of Bay 5B*, where Lewis meets Morse and Rosemary Henderson; while in *Deadly Slumber*, the characters John Brewster and Jane Folley are seen.

The Kyffin family ran the pub from 1970–1991, with David Kyffin continuing as manager after the Young's take-over. His father Syd was a champion of real ale even when this was unfashionable in the 1970s, but was once obliged by the brewery then leasing the pub to offer the tasteless keg Double Diamond. He sold only eight pints in three weeks, so the pub's patrons had taste as well as 'more brains per square inch than any pub in the world', as described by *Oxford Mail* writer S. P. B. Mais in 1957. But as Mais considered then, it was a university pub but never exclusive. 'A spirit of affability permeates the whole place,' he wrote – and that now extends to visitors from all over the world.

Lamb and Flag, St Giles

The profits made by most pubs go straight to the brewery or pub owning company that runs them, but not so with the Lamb and Flag. Owned by St John's, one of the richest of Oxford's colleges, all profits are ploughed into scholarships for outstanding students, in partnership with the university as a whole. The college, founded as St Bernard's in 1437 and becoming St John's in 1555, is right next to the pub and was dedicated to St John the Baptist whose heraldic shield is a lamb and flag.

The pub dates from around 1695 when St John's acquired an inn on this site from Godstow Nunnery, although some accounts mention an inn called the Lamb as early as 1617. Parts of the eighteenth-century building survive including a fireplace in the rear bar, with its stone flagged floor. Beside the pub is Lamb and Flag Passage, leading from St Giles to Parks Road, and this is a popular route for tourists as well as students, as it leads to the University and Pitt Rivers museums.

Several Oxford pubs have featured in works of literature, and the Lamb and Flag was one of the pubs used by the group of writers known as The Inklings, although they are more associated with the Eagle and Child, which is directly opposite on the west side of St Giles. The Lamb and Flag is mentioned in Thomas Hardy's *Jude the Obscure* (1895) where Oxford was the inspiration for the fictitious town of Christminster. A character in the novel called Arabella says, at one point, 'You may remember me as barmaid at the Lamb and Flag formerly.'

Novelist Graham Greene went to Balliol College in the 1920s, and recalls another barmaid at the Lamb and Flag in *Fragments of Autobiography*, published in the year of his death, 1991. He recalls a young woman 'who we all agreed resembled in her strange beauty the Egyptian queen Nefertiti. What quantities of beer we drank in order to speak a few words with her.'

The Lamb and Flag remains a favourite haunt of students and academics today, although 'Town' regulars and tourists come here in equal numbers. A free house, it is decorated with oars and shields from various colleges, including the St John's rowing team whose kit it used to sponsor. Unlike most city pubs it has no TV, jukebox or slot machines, and one curiosity is a clock that goes backwards showing 'Theakstons Old Peculier Time', this being one of the stronger real ales regularly available. The pub was at one time threatened with closure due to the pressing need for colleges to provide more student accommodation, but thankfully has survived and prospered.

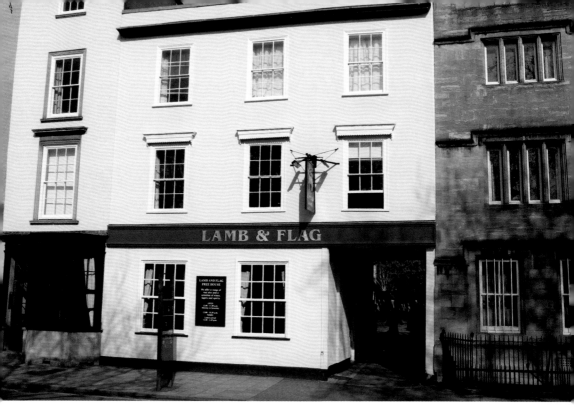

Above: The Lamb and Flag.

Right: An old photograph of Lamb and Flag Passage.

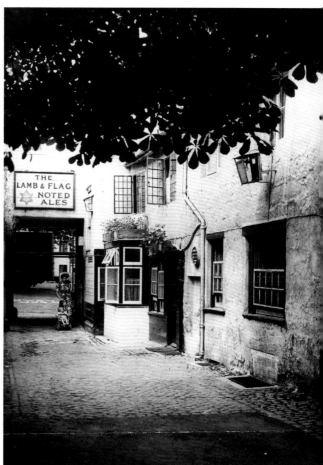

Lighthouse, Park End Street

Several pubs in and around the city have a close connection with the Oxford Canal, but you wouldn't think the Lighthouse is one of them. This name was adopted at the end of 2014 and is its fourth identity in just over twenty years, having been the Queen's Arms until 1996 and then Irish-themed Rosie O'Grady's. In 2009 the canal connection was commemorated by the name Duke's Cut, this being a channel connecting the River Thames to the Oxford Canal near Wolvercote, on the northern edge of the city. The Lighthouse stands at one corner of the Worcester Street car park which was previously part of the canal basin.

The Oxford Canal was completed in 1790 at a cost of around £300,000, running south from Coventry and alongside the un-navigable River Cherwell through parts of north Oxfordshire. It meant goods from the Midlands, especially coal, could be brought to Oxford much more easily, coal supplies previously taking a roundabout route from the North East via London, then coming up the Thames. The Duke's Cut, named after the Duke of Marlborough, was constructed at the same time, and the channel linking the canal and river by Oxford railway station was built in 1796.

The canal was an immediate success, despite being frozen solid for several months in 1795, but no-one could have foreseen how quickly the entire canal network would be eclipsed by the railways, which reached Oxford in 1844. Some goods continued to come by canal, including easily breakable items such as pottery, but a steady decline

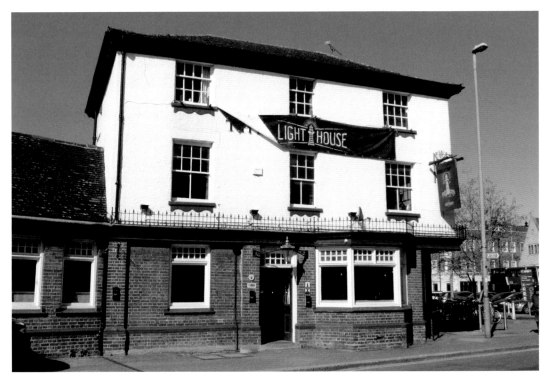

The Lighthouse.

set in throughout the late nineteenth and early twentieth centuries. In 1937 the canal basin was sold to Lord Nuffield (William Morris of car building fame), who then constructed Nuffield College on part of the site.

Research by the pub indicates that it was once an eighteenth-century tavern called Racers, and that by 1830 it was known as Navigation's End, where coal arrived from Parkend in Gloucestershire (hence Park End Street) – although coal is more likely to have arrived from the Midlands. The pub was run by James Pacey who must have been either well connected or a great character, as Pacey's Bridge is the name of a bridge over a stream at the western end of the pub, which was extended in 1977.

In 1863 the pub was taken over by William Lucas and renamed the Queen's Arms, with William's son Thomas becoming Mayor of Oxford in 1892. Even when this part of the canal basin became a car park in the 1950s, the pub continued to adapt as the pub's own history makes clear, 'Sharply dressed salesmen from the many new motor showrooms on Park End Street and rail commuters of the budding post-war middle class replaced the patronage of perspiring boatmen and greasy industrial proletariat.'

The motor showrooms are long gone, and the street is now dominated by bars and restaurants on the edge of the nightlife district. The Lighthouse describes itself as 'Nautica-Steampunk', being decorated in a maritime theme with a few old photographs from the canal age. A hearty fire still burns in an old range reminiscent of that era, with Victoriana-style lighting adding to the atmosphere.

Mitre, High Street

Despite claims by the Bear Inn to be Oxford's oldest surviving pub, this accolade rightly belongs to the Mitre, a fine old coaching inn and the only pub with a direct frontage on High Street. The Grade II listed building you see today is from the seventeenth century, with an eighteenth-century facade, but parts of the building are much older as you might deduce from the slightly lower level of the Turl bar at the rear and fragments of ancient stone wall incorporated into its rambling interior.

The Mitre is now part of Whitbread's Beefeater chain, with some of the rooms totally devoted to restaurant meals, but you can still have just a drink in the Turl bar. Here, down a busy passageway and framed on the wall, can be found a possibly original poster advertising stagecoach services. The yellowed poster advertises a 'Coach and Four' departing for London at 11.00 a.m. on Thursday mornings at a cost of fifty shillings (£2.50), which must have been a fortune in those days. No wonder passengers were advised to put their gold, silver and valuables in the coach's strongbox. 'Gentlemen are advised to carry their firearms as a precaution against highwaymen and villains now known to be in the vicinity of Hounslow Heath,' it cautions – the heath now being the site of Heathrow airport. But there were consolations, 'Many stops for Good Ale and Refreshments twix here and London'.

A chart on the wall traces back landlords to 1230, when John Pady, a Mayor of Oxford, handed over an inn on this site to his son, Philip. Parts of the building and cellars date from Saxon times, and a thirteenth-century crypt ran under the building and under the High Street. Part of it survives as a wine cellar. In 1279, when owned by

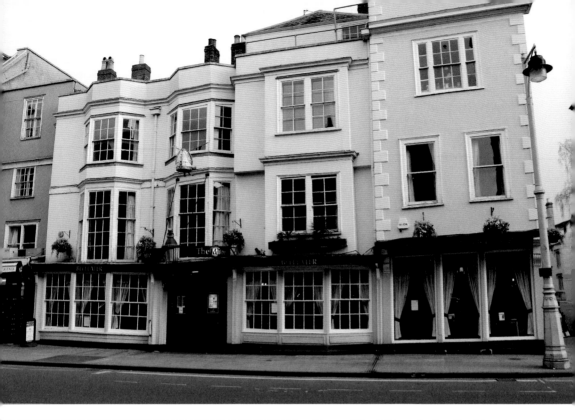

Above: The Mitre, Oxford's oldest inn.

Left: A possibly original poster at the Mitre, advertising stagecoach services (*Photo courtesy of Phil Gammon*).

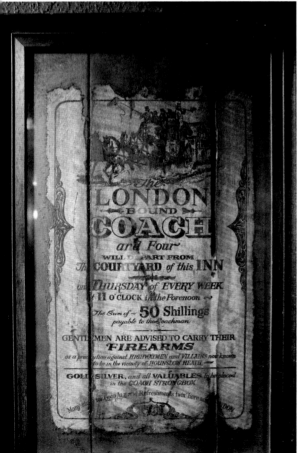

the Bishop of Lichfield, the inn was one of fourteen small shops on the site. In 1294 it was acquired by Philip of Wormanhale for sixty-seven marks, and he became Mayor in 1310 – with several more landlords of the Mitre holding this office in the coming centuries. One such was William of Burchestre (Bicester – a town thirteen miles from Oxford), landlord from 1314–1337 and Mayor on several occasions, when it was known as Burchestre's Inn. Things took a turn for the worse in 1349 when Elianore of Burchestre died of the Black Death in March, soon followed by her husband Nicholas in May. When leased to John Croxford in 1364 the pub was known as Croxford's Inn, and then as Dagville's Inn when William Dagville ran it in 1474.

Although it was recorded as the 'Miter' in 1306, it did not become known permanently as the Mitre until after Lincoln College acquired the property in 1488. The college was founded in 1427 by the Bishop of Lincoln, and a mitre, or bishop's headdress, appears on the college's coat of arms. In the seventeenth century the inn – which like most of its peers was also a hotel – became known as a place sympathetic to Roman Catholics, as noted by contemporary diarist Anthony Wood, as the college itself had Catholic leanings.

Wood notes that a man called Greene, 'a professed papist', was host of the Mitre in 1640, and at this time the crypt was used for the illegal celebration of Mass. In 1683 the landlady, Mrs Lazenby, 'died of fright caused by three rude persons', who apparently came from All Souls College just along the High Street and abused her as a 'papist bitch'. An anti-Catholic riot in 1688 was caused when T. Thorpe, the landlord, upset some visitors who then broke the windows of every Catholic home and business in town.

Things had quietened down by the eighteenth century, when it became a coaching inn – a role it continued to fulfil well into the nineteenth century. But Oxford continued to witness riots between Town and Gown as it had for hundreds of years. In 1825 the Mitre's sign and lamp were ripped down in one such riot, and the landlord forced to supply broom handles, chair legs and rolling pins for Townsmen to use as weapons. The Mitre's upper floors were good vantage points to watch such goings-on, and 'not a square inch is believed to have escaped spilt blood at some stage'.

You can muse over these events over a drink or meal in the Beefeater grill, to the somewhat incongruous background of piped music. Lincoln College has owned the pub for over five hundred years, resisting a proposal to demolish it in 1890 to widen Turl Street, still one of Oxford's quaintest thoroughfares. Other treasures on display include an old guest book for the hotel and the official uniform of the Oxford Town Crier, both displayed behind glass. The Mitre has been at the heart of Oxford life for centuries, showcasing many old photographs including the horse-drawn Burford Bus, and a picture of the High Street festooned with Union Jacks – probably for a royal occasion. Long may it remain so.

Old Tom, St Aldate's

At first sight you might think that this pub – surely with the narrowest frontage in Oxford, after the White Horse – is named after a cat. But a glance at the pub sign tells you otherwise, as Old Tom is one of the bells of Christ Church College, which dominates the southern approach to the city and whose architect was Cardinal Thomas

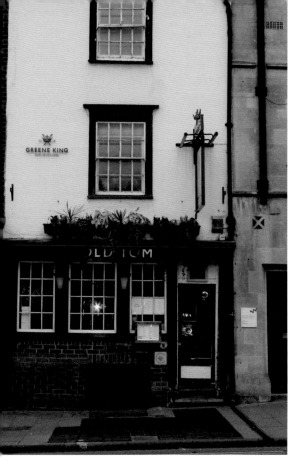

Left: The Old Tom.

Below: The Oxford Retreat.

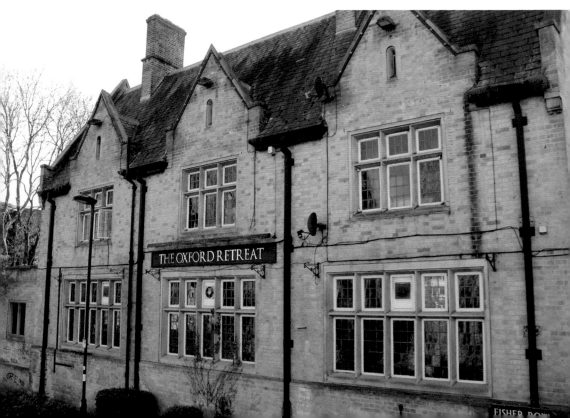

Wolsey. Its first name was the Great Tom, the original bell having been removed from Osney Abbey in 1546 after the dissolution of the monasteries, when it was brought to Christ Church. One of the curiosities of Oxford is that the bell, which weighs more than seven tons, is rung 101 times at 9.05 p.m. to commemorate the original number of students at the college, which was officially named Christ Church (after its cathedral) in that year. Even more curiously, the pub's address is 101 St Aldate's.

The pub was first recorded as the Unicorn and Jacob's Well in the seventeenth century, although a medieval inn called Ducklington's is thought to have occupied the site. The Jacob's Well name continued until 1865 when it briefly became the Great Tom, adopting the present name in 1878. The pub has only one narrow entrance for customers, staff and supplies, and is formed of two long and narrow rooms with clear glass windows facing onto the street and a small beer garden, with high walls, at the rear. The rear room is used mainly for dining, Thai food being a speciality. Suffolk brewer Greene King owns the Old Tom, this being one of many former Morrell's of Oxford pubs that it acquired in 2002.

Oxford Retreat, Hythe Bridge Street

This is the fourth identity by which the pub has been known, as it started life as the Navigation House in 1790, near the point where the then new canal widened out into a canal basin (the canal is now truncated on the opposite side of the street) – also see entry for the Lighthouse. But soon it adopted the name Nag's Head, which was to serve it well for nearly two centuries, a nag being a working horse which pulled, among other things, canal barges.

The Nag's Head was a rough bargeman's pub for most of the nineteenth and early twentieth centuries, a far cry from the somewhat sophisticated environment of today. In *Tales of Ales*, a booklet published in 1993 by Halls Oxford & West Brewery, is an account from 1911 of a visitor's impressions, 'It is an old inn. The floors are strewn with sawdust. In a shadow three men were playing cards with a pack whose every feature had been defaced by the grimy hands through which they had passed. One glance within reminded me of the drinking houses along the quayside of Marseilles.'

In the 1930s the present handsome building was erected on an adjacent site where two seventeenth-century waterside cottages had stood, on a lane called Lower Fisher Row. During the Second World War it had a poor reputation as a pub where local girls went to meet American servicemen posted to airfields near Oxford, but it continued to be popular into the 1980s with Scalextric model racing cars being an unusual pastime. In 1992 Halls changed its name to the Antiquity Hall after refurbishing it thoroughly to appeal to city workers and visitors, with the re-opening marked by a troupe in suitably Antiquarian costumes.

The most recent name change to the Oxford Retreat came in 2006, to acknowledge that the pub was now in an area renowned for its nightlife where some people might want a more relaxed atmosphere than in the clubs and bars. It describes itself as a 'pub selling cocktails' and is open until late on Fridays and Saturdays, when a DJ entertains. It enjoys a magnificent setting overlooked by weeping willow trees by a tributary of the Isis, and although it has a small beer garden this does not overlook the water.

Roebuck, Market Street

It was once one of Oxford's main coaching inns, and although nothing remains of it on Cornmarket Street, one of the main pedestrian shopping areas, the Wagamama noodles restaurant on Market Street was the former Roebuck pub at the rear of the old inn. A tavern stood here in the fourteenth century and was known as Cary Inn and Coventry Inn until 1610 when it took the name Roebuck, after the coat of arms of Jesus College which owned much of the property around here, including Jesus College Lane, later Market Street.

By the eighteenth century it was a busy coaching inn on the London to Gloucester route, the stagecoaches having exotic names including Mazeppa and Tantivy. Its size can be appreciated from a look at the street today as it is about one hundred yards from Cornmarket Street (where the frontage once was) to the building now occupied by Wagamama. Stagecoaches were effectively killed off by the boom in railway construction in the 1840s and 1850s, and in 1865 a new building was erected on Market Street called the Roebuck Vaults. This lasted only until 1924 when the original site on Cornmarket Street was acquired by department store Woolworths, and the old inn was demolished. The present building, called the Roebuck Tap, was built in 1938, while Boots' store now occupies the site of the old Roebuck Inn.

It operated as a traditional pub for about fifty years, and being right next to the Covered Market it attracted both traders and shoppers. The Covered Market is one

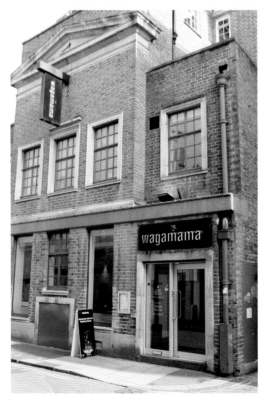

Wagamama restaurant, formerly the Roebuck Tap.

of Oxford's main attractions because of its mix of old-fashioned butchers, bakers, greengrocers and fishmongers with clothing, footwear and tourist shops, with several cafes but no pubs. It was officially opened in 1774 and improved and extended during the Victorian era, and although it continues to be busy the old-fashioned traders complain bitterly of rent increases that they say puts its character at risk.

In a fascinating account of a visit to the Roebuck in 1957, the *Oxford Times* writer S. P. M. (Stuart) Mais (1885-1975) remarks favourably on the Roebuck's mix of customers. Unusually for that era it had a restaurant and cocktail bar upstairs and a fairly extensive menu, but Mais comments that tastes were changing with fewer customers wanting a three-course sit-down lunch in a restaurant.

Mais noted 'a general air of jollity' and interviewed the Roebuck's landlord, Bill Harvey, at length. Harvey had been here since 1930, following his grandfather and mother who previously ran the pub, and he and his many regular customers greeted each other by name. Harvey is quoted as saying, 'Here we get an exceptionally happy blend of Townsmen and Gownsmen all on the best of terms with one another, dons and dairymen, butchers and bank clerks, architects and college scouts and porters: they all come here, and what I like most about them is that nearly all these locals are regulars.'

Mais – a prolific travel writer and journalist who also presented the radio programme *Letter to America* in the 1930s – described the Roebuck as 'essentially English' with no frills about it. Sadly, it didn't last as a traditional English pub and embarked on a series of name changes in the 1980s and 1990s including City Tavern, Market Tavern and Bar Oz before becoming Wagamama in 2007.

Royal Blenheim, St Ebbe's Street

Many pubs are named after battles or the victors in those battles, and so in a roundabout way is the Royal Blenheim. It is named after a stagecoach operating between London and Oxford before the coming of the railways, although that ceased to operate at least fifty years before the present handsome Victorian building was constructed in 1889.

Blenheim, in the southern German state of Bavaria, was the site of an important battle fought by the Grand Alliance (including England) in 1704 against a Franco-Bavarian army which was about to seize Vienna. The alliance army was led by England's John Churchill, first Duke of Marlborough, and his reward for a decisive victory was construction of Blenheim Palace, ten miles from Oxford in the country town of Woodstock. Blenheim Palace is one of Britain's leading stately homes and the birthplace of Winston Churchill.

By the mid-nineteenth century there were two pubs on this street, the Blenheim and the Horse and Chair, and after they were demolished the Royal Blenheim was constructed. St Ebbe's Church, named after a seventh-century saint, stands diagonally opposite the pub and dates from 1816, being on the site of a place of worship dating from around the year 1000. It stands rather incongruously by the rear entrance to the 1970s Westgate shopping centre, and is a surviving building of the old St Ebbe's district which was one of Oxford's main working class areas before being redeveloped in the 1950s and 1960s.

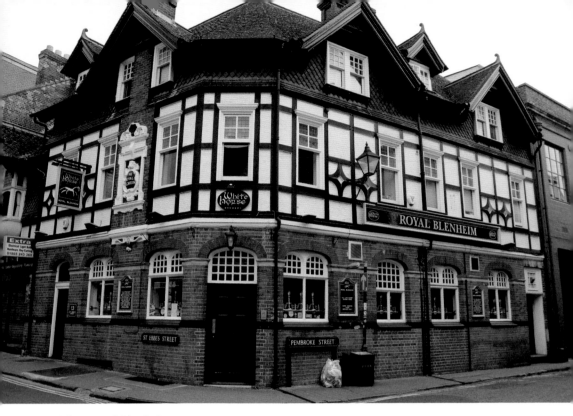

The Royal Blenheim.

This corner pub retains many of its Victorian features including the date of its construction which appears in the stonework, and the space next door which is now the Museum of Modern Art was once occupied by a brewery, with the pub functioning as the 'brewery tap'. It still functions as a brewery tap today although the brewery which leases the pub, White Horse, is actually located at Stanford-in-the-Vale, in south-west Oxfordshire, where it started brewing in 2004. It therefore claims to be the only pub in Oxford run by an Oxfordshire brewery, selling a range of beers including White Horse, Village Idiot and Wayland Smithy (named after a medieval burial site near the brewery), plus a good choice of guest ales. Decorations reflect the Welsh landlord's interest in Rugby, with major matches being shown live.

The Royal Blenheim has quite a sense of humour as the historical entry on its website proves, concluding, '... contrary to popular belief, the Royal Blenheim does indeed have a large beer garden. This can be accessed through the back of the disabled toilet at the stroke of midnight, except during the first full moon after the Winter Solstice, when it leads trans-dimensionally to a magical land flowing with beer and pork scratchings.'

St Aldate's Tavern, St Aldate's

Opposite the Town Hall and three hundred yards from medieval Carfax Tower, St Aldate's Tavern has re-claimed its role at the heart of city life since 2012, when it re-opened after one year of closure. It has been a pub for over five hundred years and has been known by five names, four of them within living memory. To make matters

even more convoluted, the original St Aldate's Tavern is further down the street towards Folly Bridge, and is no longer a pub.

A private house was first recorded on this site in the thirteenth century, and by 1380 it had become Christopher's Inn, presumably named after the landlord. This name continued until 1716 when it was rebuilt and called the New Inn, and later in the eighteenth century it had become a coaching inn on the Gloucester to London route with stabling for horses in a yard to the rear.

The New Inn name endured for nearly 250 years, with notable events including a mad dog which bit two people in 1774, causing one death; and, in 1937, becoming the first pub in Oxford to sell canned beer, for the coronation of King George VI. By this time the pub was owned by Reading brewer H. & G. Simonds, which dates back to 1785 and was acquired by Courage in 1960, with the Simonds brewery continuing until 1980. In 1965 the pub was renamed the Bulldog, not after the canine but after the university 'policemen' known as Bulldogs charged with maintaining discipline and removing students from licensed premises where they were not allowed. That restriction has long since disappeared, but you will still see a bowler-hatted Bulldog guarding the main entrance to Christ Church College a little further down St Aldate's. His job is to tell tourists where to go – to the paying entrance around the side!

Renamed the Hobgoblin and then St Aldate's Tavern in the twenty-first century, it takes its name not only from the street where it stands but a previous pub at 61 St Aldate's, right next to the Crown Court and opposite the police station. That building still stands but as a dining hall for students, its former identity as a pub being revealed by the colourful ceramic plaque in the wall of Morlands brewery, showing an artist with palette. This pub was previously known as the Apollo, and in 1997 the landlord was reported as entertaining customers with a python. There must have been a squeeze on the pub's profits, as it became a Mexican then an Indian restaurant before closure.

Thousands of people walk down St Aldate's every day without knowing anything about the saint, and indeed there is some debate over whether such a saint ever existed. St Aldate's Church stands further down the street, and is possibly named after Eldad, a priest who died in a fifth century battle with the Saxons. Aldate might also be a corruption of 'old gate', as the south gate of the city was at the bottom of the street near Folly Bridge.

Today's St Aldate's Tavern has been brought back to life by City Pub Company and is a free house noted for its real ales and freshly cooked food. The long wooden benches are popular with groups of students, and the Blue Room upstairs hosts functions ranging from TV sports to Skeptics in the Pub, which – according to the Skeptics website – is 'a group of people who like to have a drink and talk nonsense'.

It might be around one hundred years since the yard at the rear was last used by horses, but it continues to play a major role in the transport network as 001, Oxford's largest private hire taxi company, is based here. The company's multi-cultural workforce, and waiting room with rows of Las Vegas-style gaming machines, makes a nice contrast with the historical surroundings of St Aldate's, and this is a good starting point to explore pubs outside the city centre.

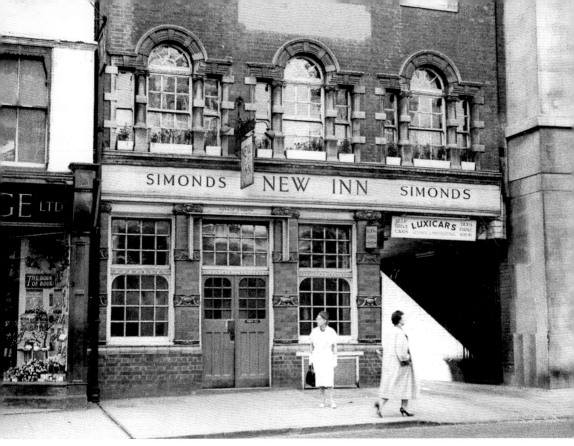

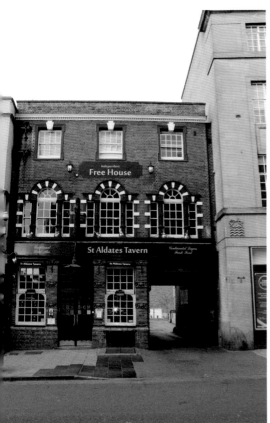

Above: View of the New Inn, now St Aldate's Tavern, from the mid-twentieth century (*Source unknown*).

Left: St Aldate's Tavern.

Swindlestock Tavern, Queen Street

Only a small plaque on the wall of what is now a branch of Santander bank tells us that on this site, on the corner of St Aldate's and right by Carfax Tower, stood a notorious tavern at the heart of the worst outbreak of 'Town versus Gown' rioting that Oxford has ever known. Riots involving students and townspeople were common during the thirteenth and fourteenth centuries, culminating in 1355 with the St Scholastica's Day riot on 10 February when students drinking in the tavern, complaining probably drunkenly about the quality of their wine, assaulted the landlord who called for assistance. Church bells were rung by both sides to summon supporters, by St Martin's for the town and St Mary the Virgin for the university.

The riots lasted for three days with Townsmen gaining the upper hand, and the depth of grievance held by many ordinary people for the university can be gauged by an account of 2,000 'countrymen' massing at the West Gate, many armed with bows and arrows. Students were attacked at inns and in their lodgings, many being killed or maimed. When order was restored many prominent people were jailed or fined, and the Mayor ordered to say a mass for the dead on every St Scholastica's Day – a tradition which continued until 1825. The riot also led to a new University Charter granted by Edward III, giving the university more powers including control over the production of wine, ale and bread – and no doubt fomenting further resentment among the poorer Townspeople.

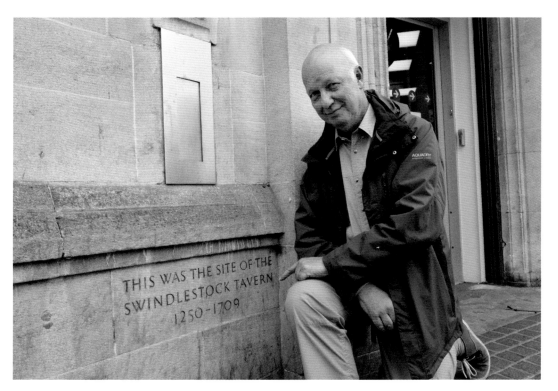

The author outside Santander bank, showing where the Swindlestock Tavern stood (*Photo courtesy of Phil Gammon*).

The plaque outside Santander states simply, 'This was the site of the Swindlestock Tavern 1250–1709'. The name relates to part of a flailing instrument used in the beating of flax. By 1664 the tavern was known as the Mermaid, but by then its days were numbered. If you want to commemorate those unhappy events today, the nearest pub is St Aldate's Tavern a couple of hundred yards away.

Turf Tavern, Bath Place

A favourite saying of a long-serving landlord here in less busy times was 'find us if you can, and you'll be back'. Despite being on the edge of the city centre the Turf Tavern is no easier to find than before, but such is its fame that almost every visitor finds his or her way here, with many using the Internet to plan a visit long before they arrive in Oxford.

There are two entrances, both narrow: down Bath Place, leading off Holywell Street; or down St Helen's Passage, once known as Hell's Passage. The easiest way to find it is to look for Oxford's 'Bridge of Sighs', a smaller replica of the Ponte dei Sospiri in Venice, which was completed in 1913 to connect the two sides of Hertford College. St Helen's Passage is just behind the bridge, to the left, as viewed from Catte Street.

The Turf promises 'an education in intoxication', and over the years many thousands of students have graduated here with honours if not gone on to take a Masters or Ph.D. Without doubt it is a very charming, though usually very crowded hostelry, although it has coped with its huge fame by installing patio seating on three sides which people seem to use in any weather. The oldest and most characterful part is by the front door, where anyone taller than about 5' 6" has to duck to enter. Immediately you know to expect an interesting sojourn, though you may have to go outside or into one of the back rooms if you want to sit down.

Along Bath Place (so-called because public baths once stood here) are seventeenth and eighteenth century cottages, some of which now form the boutique Bath Place Hotel. A malt house stood here that was serving cider by 1775, becoming the Spotted Cow Inn in 1790 incorporating part of what is now the hotel. The annual rent in 1805 was *6s 8d* (33p) 'plus two capons'. The name Turf Tavern was adopted in 1847 as it was a pub where bookmakers (also known as turf accountants) and other betting men used to meet. Bear baiting and cockfighting also attracted plenty of wagers.

The pub was built on part of a dry moat that used to run around the City Walls, and one of the last but substantial surviving parts of the Walls forms the boundary between the pub and New College, whose chapel tower overlooks the rear patio. The Walls were built around 900 to defend Oxford against Viking raids, although in 1009 a successful attack was mounted. Reminders of the Walls live on in the names Westgate (a shopping centre), Eastgate (a hotel) and St Michael at the North Gate church.

The Turf Tavern is mentioned in Thomas Hardy's novel *Jude the Obscure* (1895), where Christminster is in fact Oxford (also see entries under Lamb and Flag, and Jude the Obscure). Jude courts Arabella in a 'low ceilinged tavern up a court', whose patrons included 'a red faced auctioneer, two stone masons, some horsey men in the know of betting circles, a travelling actor and … gownless undergraduates' hoping to bet incognito. The pub described by Hardy can easily be recognised, though typical

Above: The Turf Tavern.

Right: The Turf Tavern – 'An education in intoxication'.

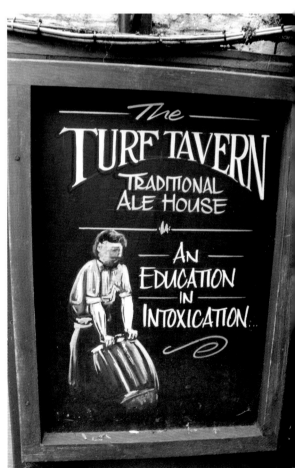

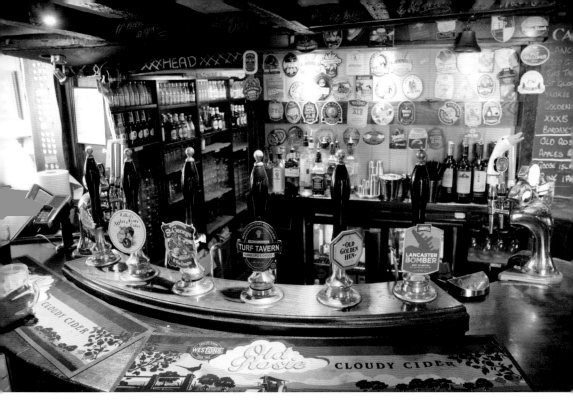

Above: Bar in oldest part of the Turf Tavern (*Photo courtesy of Phil Gammon*).

Below: The bow-tied Wally Ellse, landlord at the Turf Tavern for forty years, with a group of students trying to drink the pub dry during a Rag Week stunt in 1966 (*Photo Courtesy of Oxford Mail/The Oxford Times*).

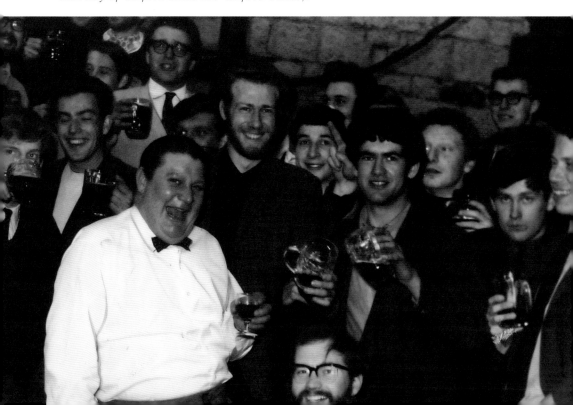

patrons have changed. This being a historic Oxford pub, it of course appears in the Inspector Morse series, including in *The Service of All the Dead*, where Morse and Lewis go into a pub called the Green Man; and *The Settling of the Sun*.

Many famous people have come here over the years, a list of whom appears on blackboards on the patio: Bill Clinton, Margaret Thatcher, Stephen Hawking, Ben Kingsley ... the list goes on, with more no doubt to follow. This may indeed have been the place where Bill Clinton drew on a marijuana joint but famously 'did not inhale' – what is for sure is that he supped pints, and certainly swallowed. Rosie the Ghost allegedly stalks the pub, and can be seen washing glasses as she awaits her husband's return from war.

The pub, now leased from Merton College by Greene King, specialises in real ale with up to eight varieties, plus three real ciders. Over the years it has had some notable landlords, especially Wally Ellse, in charge for over forty years until his death in 1986. In 1980 Wally ran a Worst Cocktail Competition, won by a mixture of Campari, Underberg and Andrews Liver Salts! Hog roasts by the City Wall and carveries were once the orders of the day; now it offers a more typical pub menu.

Wheatsheaf, High Street

Another pub that is not actually on High Street but down an alleyway on the south side (this one is called Wheatsheaf Yard and cuts through to Blue Boar Street), the Wheatsheaf is one of Oxford's premier live music venues. Performances are staged in the upstairs room four or five nights a week, including jazz, blues, folk and heavy metal, but the Wheatsheaf resists being labelled a music pub. The downstairs bar appeals to a wide cross-section of pub-goers, as long as they don't want food or the over-refined atmosphere cultivated by many hostelries these days. The Wheatsheaf is determinedly unpretentious: the Banks's Brewery slogan 'Unspoilt by Progress' comes to mind.

The building is ancient, with cottages and shops standing on this site from the thirteenth century and an inn, the Hen and Chickens, first recorded here in 1662. The Wheatsheaf name dates from 1761 and is a common name for pubs, often signifying connections with a bakery. Live entertainment was held here at that time – setting a precedent, perhaps – and landlord Charles Dodd, a college cook, was reportedly the first in Oxford to offer sausages, in 1776.

It became a music pub relatively recently, as *The Oxford Handbook* in 1980 described it as 'rather quiet and reserved for our tastes ... the piped music is so low that it gets on your nerves!' A free house for the last five years, it has created more space for drinkers by opening up the former kitchens, and removed an unsympathetic modernisation by brewer Greene King to reveal original woodwork, brickwork and the wooden ceiling.

At night, especially, a walk down the alleyway gives you a little glimpse of what medieval Oxford might have looked like. Until recently a very long-established ironmongers called Gill & Co (which itself features in *Inspector Morse*) stood opposite, but in a sign of the times this premises is now Oxford Nails (on fingers, and certainly not to be hammered).

White Horse, Broad Street

Many pubs in Oxford claim a connection with the long-running *Inspector Morse* ITV series and its successors, *Lewis* and *Endeavour*. But this quaint little pub in the heart of the university area, squeezed in by Blackwell's bookshop, has a greater claim than most – and landlady Jacqueline Paphitis has the photographs to prove it.

Morse is very much part of Oxford's tourism industry, including dedicated walking tours exploring locations in the series which depart from outside the tourist information office close to the White Horse. Morse's love of a pint of traditional bitter – a liking shared by his former sidekick Lewis and his younger self in the prequel *Endeavour* – leads him into many pubs, usually to mull over events and talk about suspects.

The White Horse appears in three episodes of *Inspector Morse*, while Broad Street, with iconic locations including the Sheldonian Theatre and Bodleian Library, appears in many more. In the very first episode, *The Dead of Jericho*, Morse (John Thaw) is seen drinking with the character Anne Staveley after choir practice – although the scene filmed inside, probably for reasons of space, does not actually feature this pub. The White Horse also appears in *The Wolvercote Tongue*, while in *The Secret of Bay 5B*, Morse is seen meeting Dr Russell before following the character Janice out into the street. Cast and crew members have also frequented the pub, including during filming of *Lewis* and *Endeavour*. It also appears in the feature film *The Oxford Murders* (2008), starring John Hurt and Elijah Wood.

Many visitors come into the White Horse purely because of its associations with these programmes, but it has many other stories to tell and is one of the oldest pubs in Oxford. It can be traced back to 1551 when Roger Scott was given a licence to run an inn called the White Mermaid, Broad Street being then named Canditch. In 1591, during the reign of Elizabeth I, it became the White Horse. Over the centuries it was also known as the Jolly Volunteer and the Elephant, although a pub with the latter name may have been on the opposite side of the street. But by the mid-eighteenth century the White Horse name had become established and it has been known as such since then.

The building we see today dates from the eighteenth century, and it is tempting to think that little has changed inside since that time as the pub prides itself on being unspoilt with few concessions to the modern era – no jukebox, TV, piped music or games machines, but a fine selection of mainly local ales, and traditional English food. It has probably the narrowest frontage of any pub in Oxford and doesn't go back very far, with the narrow door and floor being below street level. Its popularity means it can become rather crowded, but if you are lucky enough to secure a seat by the front window or in the snug at the back, then settle down to enjoy it.

White Horse is a common pub name that has associations with Hanoverian kings, especially with George I who took the throne in 1714. But the pub sign we see today commemorates a particular horse, Billie, whose story is told on a panel inside. Billie was actually grey (but appears as white in old black-and-white photographs), and was a Metropolitan Police horse. He was shown, with rider, on the pub sign between 1957 and 1978 – the current pub sign shows simply a white horse on a red background.

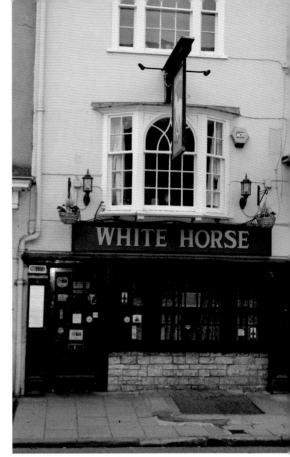

Right: The White Horse.

Below: The White Horse is surrounded on three sides by Blackwell's bookshop.

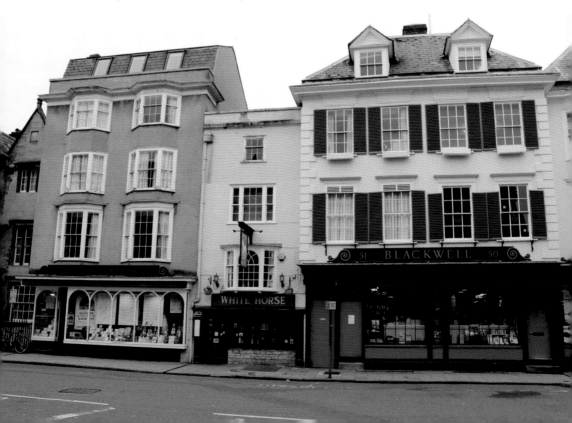

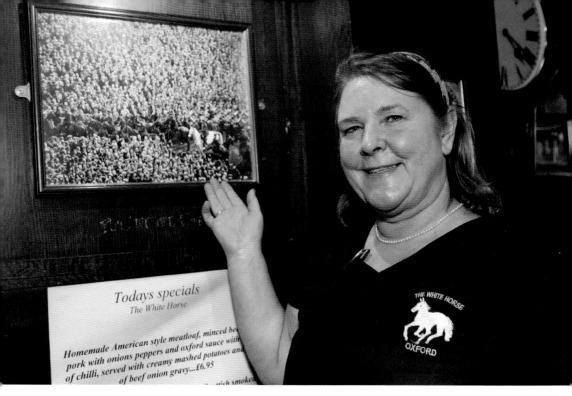

White Horse landlady Jacqueline Paphitis with the photograph showing Billie's exploits at Wembley. Photos of her with the stars of *Lewis*, *Endeavour* and *The Oxford Murders* also decorate the walls (*Photo courtesy of Phil Gammon*).

Billie helped restore order during the 1923 FA Cup Final at Wembley, when a crowd of well over 100,000 turned up and invaded the pitch before kick-off. This was the first cup final held at Wembley, with Bolton Wanderers beating West Ham United 2-0. Billie's fame is such that a footbridge at Wembley Stadium railway station is known as White Horse Bridge. A pale ale named after him is especially brewed for the pub.

During reconstruction work in the 1950s what was believed to be a 'Witch's Broomstick' was discovered plastered up behind a wall, and was promptly plastered over again by superstitious builders! According to landlady Jacqueline it remains there to this day, with a large plate covering the spot just in case the plaster should break and the broomstick falls out again … Fortunately, she has resisted the urge to call any of her beers Witches' Brew. Another notable event occurred in 1980 when a chip pan fire in the first floor kitchen almost burned the pub down.

White Rabbit, Friars Entry

Situated down an alleyway that leads towards Gloucester Green beside Debenhams' store, this pub has seen many colourful characters pass through its doors due to past associations with the theatre and rock music. Known as the Gloucester Arms (or 'Glock') until 2013, it claims to be the closest pub to a stage door anywhere in Britain, its rear entrance being only a few feet from the back of the Playhouse.

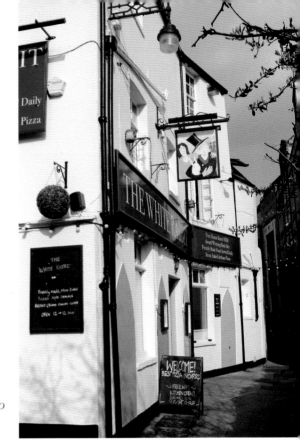

Right: The White Rabbit.

Below: As the Gloucester Arms, the White Rabbit was decorated with photos of theatre stars in the 1950s and 1960s (*Photo Courtesy of Oxford Mail/The Oxford Times*).

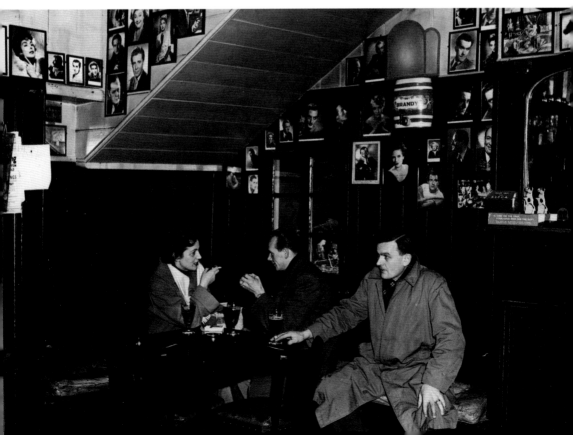

Actors and other theatre folk used to come here between scenes – sometimes in costume – with Wilfred Pickles and Dame Sybil Thorndike among those who left signed photographs on display. It had some colourful landlords too, including one called George Chitty who was known as 'the rudest landlord in Oxford' and who also ran the Perch at Binsey. More recently the Gloucester Arms became known as Oxford's rock pub with an emphasis on heavy metal and a renowned jukebox, also attracting plenty of bikers. Partly for that reason many people used to avoid it, but that changed when new leaseholders came on the scene and renamed it the White Rabbit.

It's not the only pub in Oxford to take inspiration from Alice in Wonderland, as the stories were originally written for Alice Liddell, daughter of the Dean of Christ Church where Lewis Carroll (real name Charles Dodgson) was a lecturer. But another link to the name recalled by bar staff is the song *White Rabbit* by rock band Jefferson Airplane. The song also mentions a hookah-smoking caterpillar, and by coincidence a café just a few doors from the pub has shisha pipes for people sitting outside.

It was one of five pubs that used to serve Gloucester Green market, and dates from around 1830. An annual fair took place on the third of May from 1783 to 1915 and a cattle market was held here between 1835 and 1932, meaning plenty of drovers arriving from the country keen to slake their thirst. General or antiques markets continue to be held in Gloucester Green on Wednesdays, Thursdays and Saturdays, and this is also where you'll find Oxford's coach station. Both the pub and the green were named after Gloucester College, a Benedictine hall founded in 1283. The alley is known as Friars Entry after the Carmelites or White Friars who also had a presence near here, but at one time it was also known for its brothels and by a less salubrious name.

The White Rabbit is a free house which serves local ales and a pizza menu, and landlady is Philippa Farrow who used to part-own the Ultimate Picture Palace cinema off Oxford's Cowley Road. It has a sense of humour, describing its tiny concrete patio as a beer garden despite being next to the very large beer garden of the Red Lion.

It is one of four pubs displaying a poem by Tom Wright, including the lines:

Between two rocks, where Alice dares not dwell,
Sleeps the White Rabbit, in a well-wrought nook.
Between two others, in a rocky knell,
The pub that lives where Alice dares not look

Until January 2015 there was a second pub in Friars Entry, also with a literary theme – Far from the Madding Crowd, which took its name from a Thomas Hardy novel (also see entry for Jude the Obscure). The 'Far' opened in 2002 being converted from shop units, but closed down as it could no longer afford the rent in this prime retail area. It was run by Charles Eld, former managing director of Morrell's brewery, which closed in 1998 after over two hundred years and owned many pubs around the city. The gates of Morrell's Brewery have been preserved, although the site on St Thomas Street has been redeveloped for housing.

Part II

Jericho and North Oxford

It takes ten to fifteen minutes to walk here from the city centre, and there are also plenty of buses departing from Magdalen Street.

Gardeners Arms, North Parade Avenue

Some pub names are very common, among the most widespread being Red Lion and White Hart which both have links with royalty. Rose & Crown is also fairly common (an example stands just across the road) but Gardeners Arms much less so. However, not only are there two pubs called Gardeners Arms in Oxford, but they are less than ten minutes' walk from each other in the northern part of the city – a remarkable situation at a time when so many pubs have changed their names. Both are named after market gardens that produced food for the university up until the mid-nineteenth century, and both have carried these names since opening.

The Gardeners Arms in North Parade (the 'Avenue' is usually dropped) was opened in 1872 by local brewer Morrell's, being largely unchanged until 1974 when two rooms became one long, narrow room with the bar on the right-hand side. It is decorated with old prints of Oxford and has a rarely used piano at the far end, and is renowned for its fine display of hanging baskets in the summer. Landlords David and Jenny Rhymes, who run the pub for Greene King, have been there for more than twenty years – not far behind the Halls, who own the Rose & Crown opposite.

One of many pubs appealing equally to Town and Gown, this Gardeners Arms had a novel way of dealing with the ban on students entering licensed premises, which was still in force until the 1950s. It asked students to pay an extra penny per pint for their beer, creating a fund to pay their fines if they were caught. The pub must have improved greatly since 1980, when *The Oxford Guide's* student authors were scathing about it, as for so many pubs, 'A small pub serving Morrell's bitter and an appalling selection on the jukebox. Close to St Hugh's – we would not recommend it to anyone unless they are hoping to stay at a certain college overnight.' St Hugh's was all-female at that time – you can almost hear the authors' 'nudge nudge, wink wink' …

North Parade is a delightful narrow street with a trendy, up-market feel, and a pleasant place to visit at any time. There is some controversy, however, about why it is

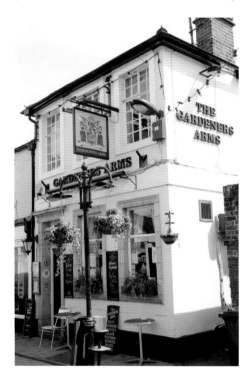

Gardeners Arms, North Parade Avenue (*Photo courtesy of Phil Gammon*).

so called. Popular wisdom is that North Parade was where Royalists massed to defend Oxford during the Civil War, with South Parade (actually north of North Parade, in Summertown) being where the Parliamentary forces used to gather. But there is no evidence this was the case, and the name probably relates to the habit of people parading up and down the street in the nineteenth century.

Gardeners Arms, Plantation Road

The older of the two pubs with the same name, it is situated on a narrow street where you feel you are in a village rather than only a mile from the city centre. This area, then known as Cabbage Hill, was covered in market gardens in the 1830s when the pub was built.

It retains the appearance of an early nineteenth-century pub, and although it is now open plan the pub's interior still feels like two separate rooms, divided by a corridor leading to a covered patio, another room at the rear, and a pleasant beer garden. Landlord Paul Silcock has old rent and repairs books behind the bar dating from the pub's earliest days, and as he has an eye for tradition there is every possibility that the pub will celebrate its bicentenary under the same name throughout – quite an achievement. It is one of several Oxford pubs owned by St John's College but leased as a free house, having survived the college's proposal to close it down in 1977 after a spirited campaign by CAMRA.

For many years it was leased by Morrell's, and had its fair share of characters both at and behind the bar. In 1975 the *Oxford Mail* carried a headline proclaiming, 'Giant

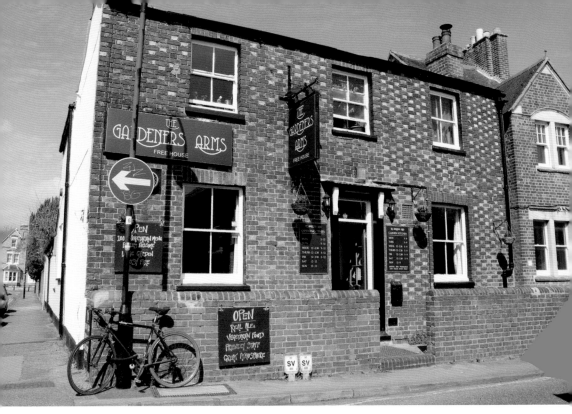

Above: Gardeners Arms, Plantation Road.

Right: What a stirrer … A 1975 photograph of Jim Smyth at the Gardeners Arms, Plantation Road, with his giant spoon (*Photo Courtesy of Oxford Mail/ The Oxford Times*).

spoon puts paid to bar room bores'. The then landlord, Jim Smyth, had moved from the Butchers Arms in Headington and brought with him an enormous wooden spoon first acquired by that pub's landlady, Rose Grain, in the 1950s. It was used to silence 'stirrers' and other bores who would ramble on about their exploits, including one customer who boasted about his prowess as a pheasant shot. How long the spoon remained at the Gardeners, and what became of it, is not known.

Unusually for such a cosmopolitan city, Oxford has no vegetarian restaurant. The Gardeners Arms goes some way towards rectifying this by having an extensive vegetarian-only menu, which is unusual for a pub and includes burgers, curries and flatbread calzones (another vegetarian pub is in Wantage, Oxfordshire, called ironically the Shoulder of Mutton). The pub enjoys an easy-going atmosphere and is much frequented by students and locals, and one of the talking points is the large collection of vinyl LP covers that adorns the walls. They come from the landlord's own collection and are mainly classic rock from the 1970s onwards.

Harcourt Arms, Cranham Terrace

Jericho had more than twenty pubs in the not too distant past, and names such as the Bakers Arms, Crown, Globe and Walton Ale Stores (the latter was once described as 'a little bigger than a matchbox') are fondly remembered, especially by older drinkers. The Harcourt Arms is where some go to reminisce as it is probably the closest in atmosphere to those old pubs, though you won't find any spit, sawdust or skittles. It retains a very traditional pub atmosphere as it doesn't serve food, with the exception of pork pies.

The pub was built by Hall's in 1871, and rebuilt in 1938 to a standard Ind Coope design with the same style and brickwork as some other Oxford pubs. It is named after

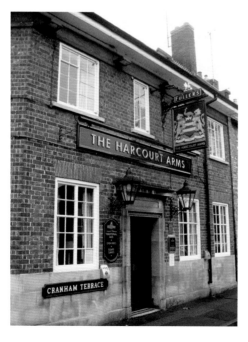

Harcourt Arms (*Photo Courtesy of Fuller's*).

local landowners the Harcourts, who also owned land around the village of Stanton Harcourt near Witney. That name has been retained since the start despite changes of ownership – it now belongs to London brewery Fuller's.

The interior is fairly modern, previously two rooms but now one, with a roaring coal fire in one corner and some rather dubious modern art prints including one above the fire put there by a previous landlord. Its longest serving landlord in recent times was John Jackman, who was in charge for seventeen years and retired in 2011; he was known as a real character. Sandwiches were served then but if you wanted them toasted, that was another 10p!

Ali Burn, the current landlord, arrived in 2014 and has kept the traditional atmosphere, including board games, while opening up the garden. His customers come from a wide cross-section of society including students, people working at Oxford University Press, and of course long-time Jericho residents. The pub has changed with the times, and the two-up, two-down terraced houses around it – once homes to print and other manual workers – now change hands for half a million pounds.

It's a very welcoming pub, a far cry from 1980 when the student authors of *The Oxford Handbook* wrote, 'They were not pleased to see us here. In fact, if looks could kill, there might have been no pub guide!'

Jericho Tavern, Walton Street

One of Oxford's premier rock music venues – where local bands including Supergrass and Radiohead cut their teeth before becoming famous – the Jericho Tavern can trace its history back to 1650, when a house was built on the site of Jericho Gardens. It seems to have become a pub when diarist Anthony Wood visited in 1668, when the area would have been outside the city. He spent *6d* – a fair sum in those days. A Surgeon Bristow was recorded as offering smallpox inoculations here in the 1770s, while in 1818 landlord William Higgins was operating his own brewery. Oxford's main brewer Morrell's, taking out a competitor, closed this brewery after acquiring the pub in 1871.

It appears to have traded comfortably through two world wars, but by the late twentieth century it embarked on changes of name and identity before reverting to its original name. In the 1950s/1960s it was known as the Jericho House, but in the 1960s it became a steak house, the Berni Inn, which operated on the upper floor where rock bands now perform. But the ground floor remained a bar, this arrangement continuing into the 1980s when it became the Jericho Tavern. A Nurses Social Club was offering cut-price drinks here in 1982, when the Radcliffe Infirmary just down the road was still open. The pub appears in *The Silent World of Nicholas Quinn*, the second Inspector Morse episode, when Lewis drops Morse at the cinema next door (then Scene 2, now the Phoenix) but Morse goes into the pub instead.

In 1984 it was operating a women-only bar upstairs, a nice reversal of the 'men only' pubs that were widespread in the first half of the century. But this attracted controversy when it was closed down by the landlord, who complained that some of its patrons 'smoked marijuana and kissed'. A letter to the *Oxford Mail*, signed by 'A

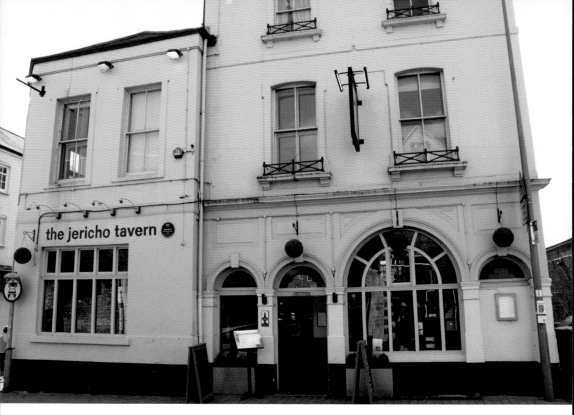

Above: Jericho Tavern.

Below: Pulp was one of the bands to start making it big at the Jericho Tavern.

Proud Lesbian', defended women's right to kiss – but the 'women only' arrangement was not reinstated.

By the mid-1980s it was really getting into its stride as a rock music venue, but this attracted many protests from neighbours affected by noise. In 1986 it was ordered to install costly soundproofing measures, which were so successful that people in the bar downstairs were hardly aware of what was going on above their heads. This was a great relief to rock fans, who had organised a public meeting at the Town Hall to highlight the dwindling number of venues putting on live music. Another pub in Jericho, the Radcliffe Arms, was similarly affected by protests over noise.

In 1995 the Jericho Tavern was taken over by Allied Domecq's Firkin Brewery and renamed the Philanderer and Firkin, although unlike most Firkin pubs (another was the Philosopher and Firkin in Cowley Road, now the City Arms), it did not have its own micro-brewery. Rock fans feared live music would take a back seat, as live sessions were cut back to three a week.

Now owned by Mitchells & Butlers, the pub is hoping to re-emphasise its standing as a prime rock music venue despite competition from the O2 Academy, Wheatsheaf and other venues. The main wooden-floored bar downstairs has posters advertising appearances by Radiohead in 1991, Pulp and the Blood Oranges on an unknown date (entry £3.50) and Carter ('The Unstoppable Sex Machine') in 1989. Rising local band Stornoway appeared here in 2007 and Mumford & Sons in 2009, just as the latter were becoming famous. On the wall outside is a Music Heritage Award plaque erected by songwriters' organisation PRS for Music, recording that Supergrass first performed here in 1994. The stage upstairs is probably the largest in an Oxford pub, and if you want some fresh air, the pub has a rear garden.

Jude the Obscure, Walton Street

The pub you see today would not appear to have a long history as it is thoroughly modern both inside and out, but appearances can be deceptive. It was built in 1871 as the Prince of Wales and was much smaller than now, until 1978 when it was modernised and expanded by Morrell's Brewery which had acquired adjoining terraced houses. The official re-opening was attended by the Sealed Knot Society, which does Civil War re-enactments, with Morrell's chairman William Morrell pulling the first pint.

A new landlord, Irishman Noel Reilly, arrived in 1995 and renamed it Jude the Obscure after Thomas Hardy's novel. This was an inspired choice as the novel is set in the fictitious town of Christminster, modelled on Oxford, and mentions real pubs in the city including the Turf Tavern and Lamb and Flag. The Jericho area is known as Beersheeba in the novel, which was published in 1895. The late Noel Reilly was a great patron of the arts, hosting plays and poetry readings, with an artist using a studio upstairs. He later opened a new pub with ex-Morrell's boss Charles Eld – Far from the Madding Crowd, again named after a Hardy novel. That pub, in the city centre, sadly closed in January 2015 due to steep increases in rent.

The Jude today is a bright, busy, airy pub with rear patio, and a couple of outside tables at the front from where to observe Walton Street life.

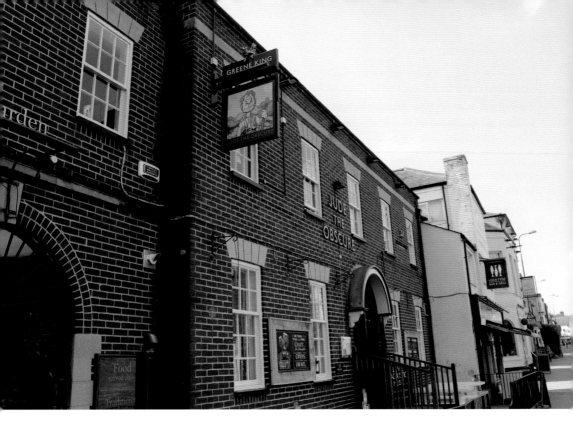

Above: Jude the Obscure.

Below: The Prince of Wales, before it was extended by acquiring the neighbouring houses. It is now Jude the Obscure (*Photo Courtesy of Oxford Mail/The Oxford Times*).

Old Bookbinders, Victor Street

We all know that Inspector Morse liked a drink, and this is where we first see him going for a pint. The first episode (1987) is called *The Dead of Jericho*, and many scenes were filmed around here when the pub was called the Bookbinders Arms. Morse and Lewis are seen going into the pub, but the interior scene was actually filmed elsewhere. Directly opposite is Combe Road, a short street of terraced houses leading to the canal, where the characters Anne Staveley and George Jackson lived, and where the denouement was filmed.

This is claimed to be the only pub in Britain called the Bookbinders, reflecting the rich publishing history of Jericho which was already established before Oxford University Press (OUP) opened its classical headquarters in nearby Walton Street in 1830, when it became Oxford's largest single employer. The pub's own research indicates that the number of printers or bookbinders in the area increased from ten to ninety between 1806 and 1835, with the close-packed terraced streets of Jericho being built to house workers in publishing, the canal trade, and other industries. Combe Road was known as Ferry Road until 1959, when it was named after OUP printer Thomas Combe who helped finance the building of adjacent St Barnabas Church.

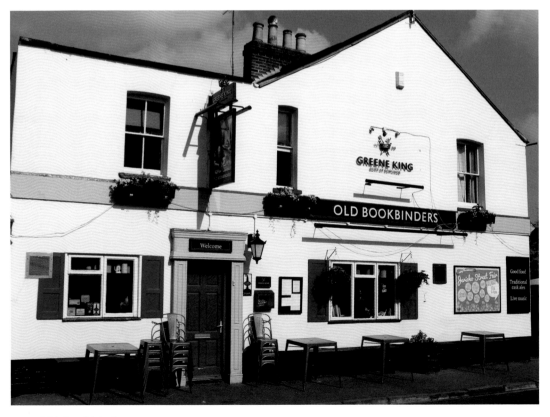

Old Bookbinders.

Above: Music Room at the Old Bookbinders (Photo courtesy of Phil Gammon).

Below: Josh Mullett-Sadones of the Old Bookbinders (*Photo courtesy of Phil Gammon*).

The pub was at one time known as the Printer's Devil – or apprentice – and was built in 1869, being acquired by Morrell's Brewery in 1881 in whose hands it remained for over a century. Visitors expecting to see where Inspector Morse sat will be disappointed, but the interior is the most quirky in Oxford being a jumble of bric-a-brac including part of an ancient model railway upside down on the ceiling, and a barrel offering free monkey nuts in shells. Ales used to be dispensed direct from the barrel as well as from hand pumps, but this is no longer the case as ales straight from the barrel can be lukewarm in hot weather. The rear or music room, not always open, has LP covers and more memorabilia.

Fortunately the pub's character was not altered by the new tenants (of Greene King brewery) who arrived in 2011 to run their first pub. Their experience running restaurants in Oxford has been put to good use by the French chef and owner, aiming to provide restaurant meals at pub prices. It attracts a very mixed clientele, and you might find a party lingering over a three-course meal at one table, and drinkers playing board games at the next.

It is one of several Oxford pubs to feature the works of local poet Tom White framed on the wall. His ode to the pub ends with the lines,

I come to that long longed-for friend-per-mile
The Old Bookbinders Ale House, and I smile

The pub is close to the canal (a bridge leads over to the towpath beside flats on Canal Street, a couple of hundred yards away), and can be incorporated into a waterside walk including the Perch and the Trout Inn.

Rickety Press, Cranham Street

As the Radcliffe Arms, this pub was at death's door when closed in 2010 and seemingly destined to become a private house like many other Jericho pubs, including the former Bakers Arms, on the corner diagonally opposite. It was opened in 1872 by NBC Brewery of Northampton and more recently came under the ownership of Scottish and Newcastle. It had been regarded as a good locals' pub, with a traditional sing-song held every Sunday around the piano in the lounge, but trade declined and various changes of style failed to work. The 'Raddy', as it was known, was at one time a music pub and its last guise, under the original name, was as a pub and Thai restaurant, under the same management as the Old Tom in St Aldate's.

Fortunately, Arkell's Brewery of Swindon acquired the pub and spent a great deal refurbishing it to a high standard, including a conservatory, re-opening it in 2011. It is under the same management as the Rusty Bicycle in east Oxford, taking its new name from Jericho's long history of printing. The Radcliffe Arms name comes from John Radcliffe, the eminent seventeenth century physician after whom the nearby Radcliffe Infirmary and Radcliffe Camera library were named, and whose name is remembered today at the John Radcliffe hospital.

The Rickety Press concentrates on food, and might be considered a gastro-pub. The part nearest Cranham Street feels more like a pub and is lined with books.

Rickety Press.

Rose & Crown, North Parade Avenue

Oxford has an abundance of character pubs, but this could almost be in a class of its own. Its journey from basic boozer to historic hostelry over the last thirty years is a story in itself, and it can now be regarded as the finest traditional Victorian pub in the city – a place where you might step back in time, but where the atmosphere is never twee. Landlords Andrew and Debbie Hall, who run the pub with their son Adam, have been here since 1983 and are believed to be the longest serving landlords in Oxford for continuous service at one pub.

This part of Oxford was open fields in the early nineteenth century with the land between the roads to Banbury and Woodstock let out as market gardens, by owner St John's College. The land was parcelled up and sold in the 1830s, and in 1836 two lots were acquired by Daniel Stokes, who built a cottage and is recorded as being a market gardener in the censuses of 1851 and 1861. He opened an alehouse in 1863, acquiring the name Rose & Crown in 1867. At that time it had only one room with the Stokes family living in the cottage to the rear. In 1877 it was sold to Halls Brewery, with Daniel's son Thomas continuing as tenant. The Stokes family connection lasted until 1928, notching up sixty-five years of service. Arthur Woodward became licensee in 1925, and with Elsie Woodward taking over from 1956 to 1976, that family completed forty-one years.

In 1954 the pub narrowly escaped forced closure, with various character witnesses testifying before the annual Oxford licensing sessions in support. The licensing inspectors had described it as 'very ramshackle' with an 'appalling' kitchen and

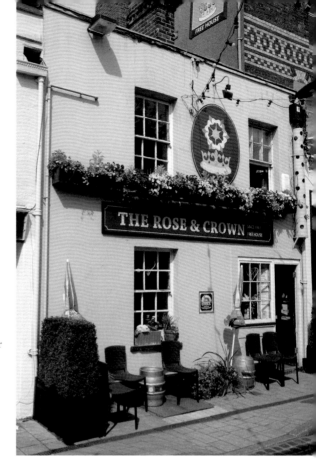

Right: Rose & Crown (*Photo courtesy of Phil Gammon*).

Below: Pictured in 1983, soon after they arrived at the Rose & Crown, are Andrew and Debbie Hall (*Photo Courtesy of Oxford Mail/The Oxford Times*).

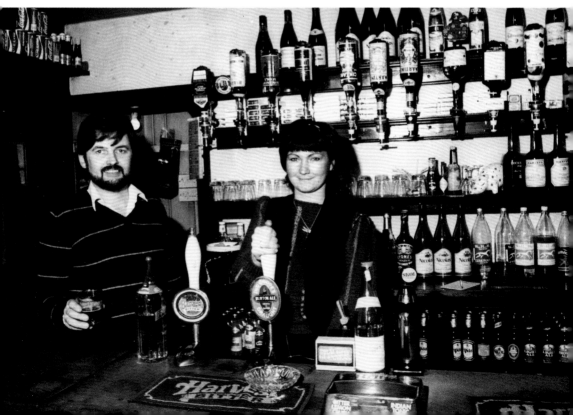

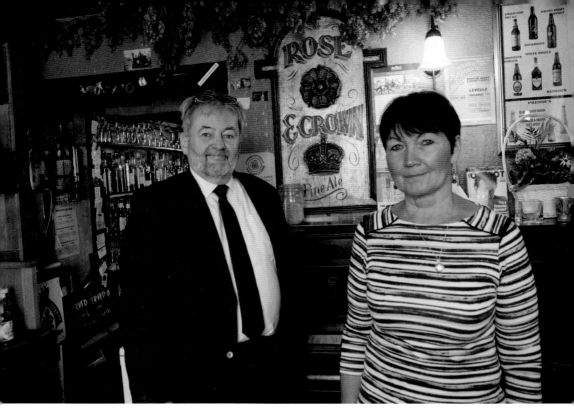

Andrew and Debbie Hall at the Rose & Crown: Oxford's longest serving landlords (*Photo courtesy of Phil Gammon*).

'dreadfully damp' living quarters, but the police had no problems describing customers as 'respectable and decent'. The pub ran a Thrift and Slate Club with fifty-two members, and a bar billiards team. Arthur Woodward was paying £26 per year in rent to Halls Brewery, and £68 in rates. The brewery testified that sales amounted to 576 pints of beer a week, and nine bottles of wine or spirits – a typical ratio for that time. About fifty customers a day were served.

Those who spoke up in support of the pub included a composer, John Beale, who said, 'The conversation which took place there was of an exceptionally high level. It was sometimes cultured, sometimes flippant, and witty.' The secretary of the Thrift and Slate Club, George Green, said all classes of people used the pub. The authorities, after an adjournment, relented on the closure proposal. Over one hundred people had signed a petition in support of the Rose & Crown continuing in business.

The Rose & Crown was still a basic pub when Andrew and Debbie Hall arrived in 1983, and the young couple had plans to liven it up by installing a jukebox and fruit machines, as at their previous pubs in Cheltenham and Birmingham. The pub did not even have a proper till or glass washer at that time, and to the rear, where there is now a heated patio, there was only a grassy mound with just one table. But their regulars, and there were many, said no to a change in style – and to this day the Rose & Crown is a haven of tranquillity with no TV, music or machines. This part of North Oxford attracted a fair number of eccentrics who certainly gave the pub atmosphere. One the

Halls remember in particular was poet Elizabeth Jennings (1926–2001), who wore a plastic mac in all weathers and talked incessantly.

The orange wallpaper and green lino soon went, and the black paint covering the woodwork was removed as the Halls set about restoring the pub. By the 1990s it was increasingly hard for a pub to make a living, with a growing number of closures. But the small, two-roomed Rose & Crown was gradually restored to its Victorian appearance, with long wooden benches in the bar and the passageway outside, and a heated patio opened up to more than double the number of seats. Ownership changed several times between breweries and the 'pubcos' who took over many of their properties, but the Halls bought the business as a free house in 2009 and set up a new company called Halls Oxford Ltd, recalling the Halls Brewery that first owned the Rose & Crown in 1877.

There is much to occupy an hour or more here, with a bistro-style menu (or pickled eggs if you prefer!), a large collection of books and board games, and many sporting mementoes especially from Rugby and ice hockey. A team from the pub became world champions at Dongola racing, using punts with paddles rather than poles and teams of six people. Proof that the Rose & Crown has reached the heights comes with a photograph taken on Everest by a former Nepalese chef, who unfurled a banner in the pub's honour.

Royal Oak, Woodstock Road

Many old pubs standing beside main roads used to be coaching inns, but this one started as a blacksmiths. The oldest part is the bar to the left of the main entrance, which has an ancient fireplace and is known as the Wheelwright's Forge. The blacksmith, or wheelwright, attended to coaches and other traffic, at a spot which was described as desolate in 1756 when a cottage first stood here, despite being so close to the city. Woodstock Road was also the haunt of highwaymen.

The blacksmith's name was John Morris, from Woodstock, and he rented the land from St John's College. His son Thomas followed him into the business in 1770, by which time an alehouse had probably developed in a series of little cottages which eventually made up the substantial stone building we see today. Not only did the family attend to coaches, waggons and carts, but also served drinks, baked cakes, and offered provisions to coaches heading north. Other inns opened to serve the same passing traffic – one called the Diamond House of which there is no trace, and another called the Horse and Jockey which stood to the right of a small parade of shops a couple of hundred yards to the north. That has since become housing, called the Old Horse and Jockey.

An old oak tree that stood nearby may have suggested the name, but there are many pubs called Royal Oak, usually after Charles II who escaped from the Battle of Worcester in 1651 by hiding in an oak tree. He had been defeated by Cromwell and lost his crown, and his picture, shown in an oak's branches, appears on the pub sign.

Some of its walls are nearly two feet thick, but it has been extended to the rear and to the right-hand side in recent years. It is a large, rambling pub made up of several rooms, with some interesting stained glass portraits near the entrance. Another portrait, above the bar, is identified as the composer Haydn. A nice old photograph displayed just inside the entrance shows a group of horse-drawn drays belonging to Halls Brewery outside the pub, and the Halls Hare sign is still in place outside long after the brewery closed.

Above: An old photograph showing horse-drawn drays of Halls Brewery outside the Royal Oak (*Source unknown*).

Below: Royal Oak.

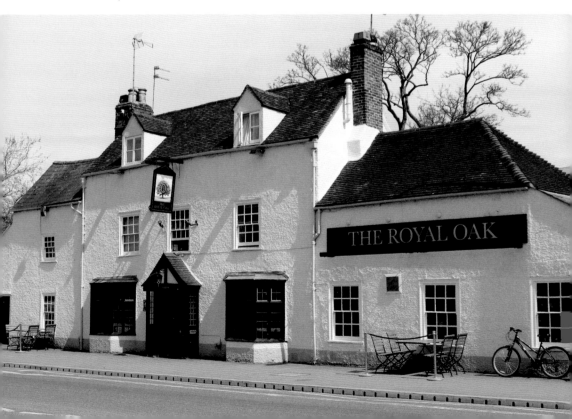

The pub's clientele is mainly academic and professional, but no longer includes the many doctors, medical students and nurses who used to frequent it before the eighteenth century Radcliffe Infirmary, just across the road, was closed. The façade remains and the site is being redeveloped for university use. The Royal Oak used to attract a wide range of customers, as noted by the writer S.P.B. Mais in an *Oxford Mail* article published in 1957 with the headline, 'At the Royal Oak you may find your neighbour is a drayman, a doctor or a duke'. He described it as one of the friendliest inns in Oxford, with as wide a cross-section of customers as any pub, united by a common interest in sport.

Victoria, Walton Street

This early Victorian building, a landmark in the Jericho area, is handsome enough in itself, with its red and grey brickwork and terrace overlooking Jericho's main thoroughfare. But it is only when you go inside that you appreciate how unusual it is. There can't be many pubs with a reproduction of a classical painting adorning the ceiling, even if, on closer inspection, the two main figures depicted are holding glasses of beer!

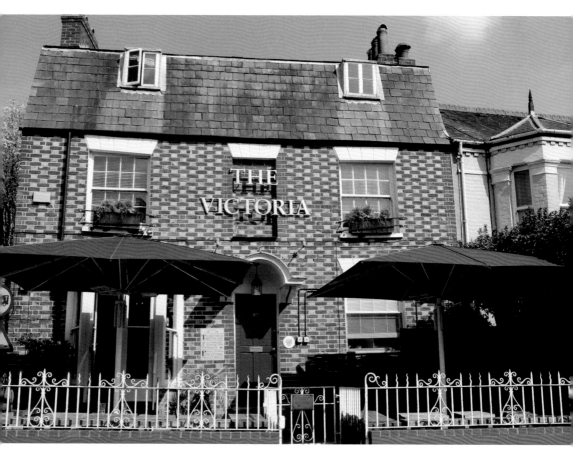

Victoria, Walton Street.

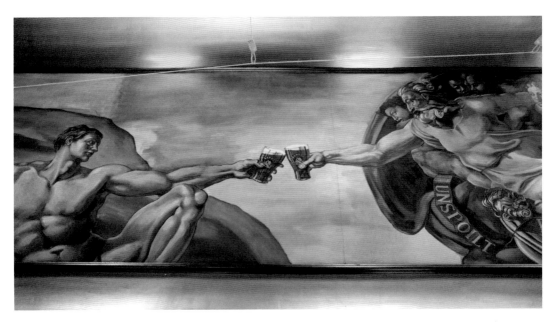

Michelangelo's *The Creation of Adam* adorns the ceiling of the Victoria in Walton Street – with a difference! (*Photo courtesy of Phil Gammon*).

It was one of the pubs constructed by Oxford brewer Halls, in 1839, at a time when the area was fast developing. Oxford University Press had opened its new building in Walton Street in 1830, and the Victoria was one of many Jericho pubs catering to its workers although, even at that early stage, it was grander than most of its rivals. It was once used for meetings of the Oxford Anglers' Association and also hosted meetings of the university Writers' Club, which included Dylan Thomas among its members. Another regular was the comic actor Dudley Moore, who sometimes played the piano in the Snug bar. But it has never had such close associations with the university as some pubs, and today it continues the tradition of appealing to Town and Gown alike with the rear garden being particularly popular on fine evenings.

The interior is eclectic, with bric-a-brac including boxing gloves, a large model aeroplane and what appears to be a fox's head wearing a fez. But what really draws the eye is the painting on the ceiling, and this is far above eye level as the upper floor has been cut back to create an extended balcony (some call it a minstrels' gallery) running right around the interior of the building.

The painting is based on Michelangelo's *The Creation of Adam*, probably the best-known fresco at the Sistine Chapel in Rome. It was made around 1512 and shows God, surrounded by angels, reaching out to touch Adam who wears an expression of innocence and calm. There's a subtle (or not so subtle) difference with this version, however – God and Adam are apparently toasting each other with glasses of beer. If you know about the recent history of brewing then you will recognise the slogan draped just beneath the figure of God – 'Unspoilt by Progress'.

This was used to advertise Banks's Brewery of Wolverhampton for many years, with the TV version intoned in a marked Black Country accent. The painting dates from the 1980s when the Ellse family sold it to Banks's, and the pub is now leased from Marston's which continues to brew Banks's bitter. Whether Adam is indeed unspoilt by progress is a moot point, one that can no doubt be debated over a pint or two of real ale as long as you don't get a crick in your neck.

Part III

Around The Plain

The Plain is a roundabout at the end of Magdalen Bridge, which can be reached in ten to fifteen minutes' walking time from the city centre. More pubs can be found down Cowley Road and Iffley Road.

Angel and Greyhound, St Clement's Street

Virtually nothing remains of two old coaching inns that used to stand near the Magdalen Bridge end of the High Street, but their names live on in this large pub just across the bridge in St Clement's. Angel and Greyhound Meadow, an open space popular with dog walkers and picnickers, can be reached via the public car park at the rear of the pub. The meadows were used to graze and provide fodder for horses used by coaches and guests at the two inns, being leased from Magdalen College in 1585.

The Angel was the older of the two inns, standing on a site now partly occupied by the University Examination Schools. First recorded in 1391 when known as the Tabard (this being a herald's tunic), it became the Angel in 1510 and was rebuilt and enlarged in 1663, most of the original building being demolished. The Angel's heyday was during the eighteenth century when long-distance travel using coaches and horses became widely available, and at one time ten coaches set out for various destinations at eight o'clock each morning heading north, south, east and west. Merton Street, running parallel to High Street behind the Examination Schools, was at one time known as Coach and Horses Lane.

Many notable visitors were recorded, including the Prince of Tuscany in 1669, the King of Denmark, Christian VII, in 1768, and Queen Adelaide, consort of William IV, in 1835. At one time it was accommodating up to 13,000 guests a year, an average of thirty-five a day. But the Angel was closed in 1866, when Magdalen College sold it to the University, with the Examination Schools being completed by 1882. The former servants' quarters at the city end of the old Angel were split into separate buildings, one becoming a grocery shop where Frank Cooper's Oxford Marmalade – still an international brand today but not produced here since 1967 – was first made in 1874. That is now the Grand Café.

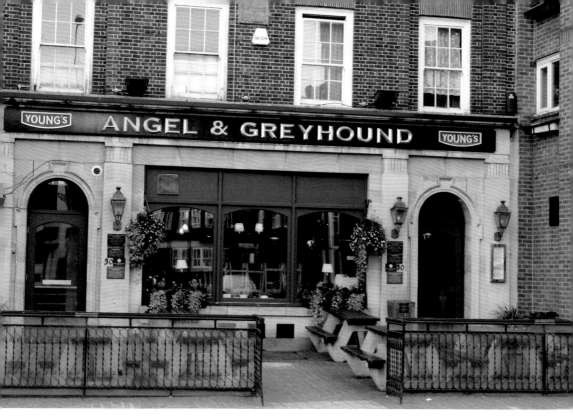

Above: The Angel and Greyhound.

Below: The 1979 'punk photograph' at the Angel and Greyhound – unusual wallpaper!

On the opposite side of High Street, on the corner of Longwall Street nearer Magdalen Bridge, stood the Greyhound Inn, first recorded in 1526 as the Cardinal's Hat but becoming the Greyhound by 1535. It lasted until 1845 when expansion of its owner, Magdalen College, swallowed it up. A guest recorded in 1669 was Elias Ashmole who went on to establish the Ashmolean Museum, now one of Britain's leading art collections.

The Angel and Greyhound in St Clement's was first established as a beer house and off-licence in 1880, although a private house and sweet shop had stood here since about 1830. According to rumour, 'rollers' were put under the foundations so that these buildings could be pushed forwards or backwards depending on what else was planned for the street, and the pub is set back from the road unlike its neighbours. It became the Burton Ale Stores in 1920 and the Oranges and Lemons in 1970. This refers to a London nursery rhyme believed to date from the eighteenth century, which includes the lines:

Oranges and Lemons, say the bells of St Clement's
You owe me five farthings, say the bells of St Martin's

The new name in 1970 established a connection with the Oxford parish of St Clement's, originally a village outside the east gate of the city. A church of that name stood on The Plain until replaced by a new church, further away on Marston Road, in 1826. A fine black and white photograph acting as wallpaper in the pub shows a large group of regulars outside the Oranges and Lemons in 1979, and was taken by a student called Steve Blackman. Even today some people in the photo still come in, and a Buddhist wake was held here for one of them. The photo is a fascinating snapshot of the times, with some of the customers sporting the then fashionable punk look. It used to be a leading punk pub, with performers including Billy Idol of Generation X. *The Oxford Handbook* noted in 1980, 'The atmosphere is wonderful. Have a chat with the tramp warming himself at the coal fire. Gaze at the punks with hair all colours of the spectrum.'

In the mid-1980s it became Parker's, one of Oxford's first cocktail bars, with TVs on every wall. That wasn't successful, and in 1991 it was taken over by Young's brewery and renamed the Angel and Greyhound. Richard and Kathryn Gibson, the landlords, have been dispensing good cheer as well as drinks since 2003.

Cape of Good Hope, The Plain

This large, imposing pub has had multiple identities over the last twenty years, but has since reverted to the name first bestowed on the original pub in 1785, continuing after it was rebuilt in 1892. The cape itself is generally believed to be the southernmost tip of Africa, but this is in fact ninety miles away. It is however the point where a ship rounding Africa begins to turn east rather than south, and has been a sailors' landmark for centuries.

Various theories have been put forward about why the pub is so-called, including the British conquest of South Africa and the pub's hopes for future success. Or perhaps

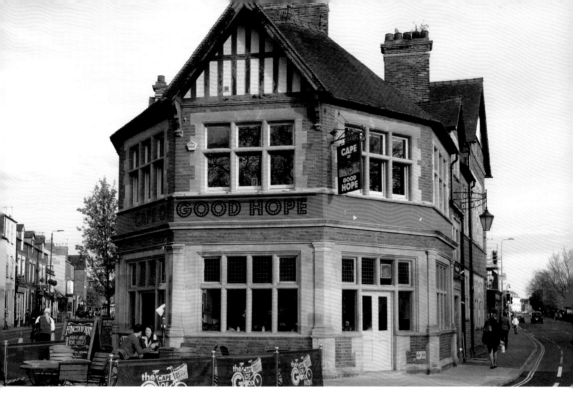

Cape of Good Hope (*Photo courtesy of Phil Gammon*).

the name refers to its position at this busy road junction, as it juts into the roundabout like a promontory.

The Cape has always been popular with students, and was known for live music by the 1970s. Curiously, in 1992, Morrell's declared that it would become a student-only pub because of attacks on students in some other pubs – almost an echo of the Town versus Gown riots in past centuries. Later in the 1990s it was acquired by Wychwood Brewery of Witney and renamed the Hobgoblin, after its best-selling beer, which you can still enjoy in several Oxford pubs. It was then sold on to gain the uninspiring name The Pub Oxford, with the nightclub upstairs known as The Point. The pub sign showed Edvard Munch's famous painting *The Scream*, with the slogan 'It's a Scream'.

It has now returned to its roots, with a bright, café-bar style, many students and young 'townies' among its regulars, and live music upstairs twice a week. This is one of the pubs to open at 5.00 a.m. on the morning of 1 May, when people flock to the bridge to watch choristers from Magdalen College singing from the top of the Great Tower. This highly popular event is still a traditional celebration of spring, although the habit of some students to jump off the bridge into the shallow River Cherwell, sometimes with crippling consequences, has caused great concern.

Half Moon, St Clement's Street

Once a contender for the title of 'smallest pub in Oxford' but enlarged in 2001 by acquiring the property next door, the Half Moon is one of the city's great character pubs and a real throwback. It is hard to put your finger on what makes it special,

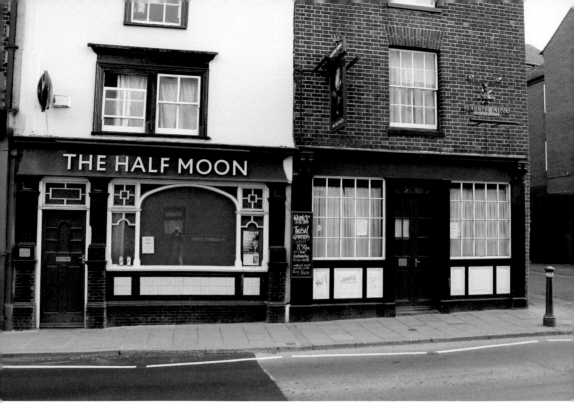

Above: Half Moon.

Below: The 'newer' part of the Half Moon (*Photo courtesy of Phil Gammon*).

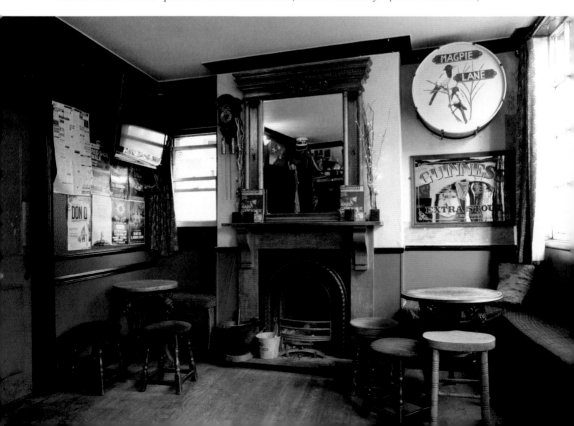

In the money at the Half Moon (*Photo courtesy of Phil Gammon*).

but the atmosphere is usually very relaxed and friendly, and the decor – including hundreds of old bank notes and mementoes of some of the bands that have played here – genuinely retro. It is open from 5.00 p.m. to 2.00 a.m. at night, attracting staff from many other pubs on their way home. It's a place to unwind, listen to music and celebrate the traditional pub, and doesn't serve food.

Live music can be heard several nights a week including folk on Sundays, jazz and 'open mike' nights, and anyone is welcome to tinkle at the piano or strum a guitar in the corner of the original room. The accordion and violin on display above the bar recall its previous image as an Irish pub when run by long-serving landlord Joe Ryan, and some of that atmosphere remains although it is now more cosmopolitan.

The Half Moon is the closest pub to Magdalen College and attracts plenty of students and university staff, but this is a pub that attracts people from all walks of life. It is easy to picture the pub in Victorian times, although it dates back slightly further to 1823. Beer barrels were once used as seats and tables, when fifty people would often crowd into the one-room pub, cheek by jowl. It can still get busy, and has lost little of its character by incorporating the shop next door which is of similar vintage.

Mad Hatter, Iffley Road

It has only been known as the Mad Hatter since 2013, with perhaps the most innovative and unusual approach to reinvigorating a pub yet seen in the city. But for many people it will always be the Cricketer's Arms, the name which is literally set in

Above: The Mad Hatter, formerly the Cricketer's Arms (*Photo courtesy of Phil Gammon*).

Below: Joe Liddell acts as mother at the Mad Hatter (*Photo courtesy of Phil Gammon*).

stone on the plaque facing Iffley Road and above the original door around the corner on Circus Street.

The image of a cricketer that faces Iffley Road, while it may be generic, is said to commemorate a superstar of yesteryear – the great Don Bradman (1908–2001), considered by some to be the greatest ever Test batsman. Bradman, memorably described by his countryman and singer-songwriter Paul Kelly as 'more than just one man, he was a match for any side', was a legend. His test batting average over a long career of 99.94 fell tantalisingly short of 100, but was still enough for him to be hailed as one of the greatest practitioners ever of any major sport.

Bradman's connection with the city is that he played for Australia against Oxford University at the Christ Church cricket ground in Iffley Road, opposite the pub. An even more remarkable event in Iffley Road's sporting annals is Sir Roger Bannister becoming the first man to run a mile in under four minutes, in 1954. Bradman toured England several times with Test teams in the 1930s, and during the 1930 tour he hit 254 runs in the second test and a 'century' (100 runs) before lunch in the third. Although the pub was built in 1880, it was rebuilt and enlarged in 1936 by Morland Brewery, when the plaque showing a cricketer was added.

Morland, in nearby Abingdon, closed in 2000 after take-over by Greene King. But many of its pubs in Oxfordshire, both open and closed, still display on the outside wall the colourful Morlands Artist plaque, depicting an artist in eighteenth century garb with palette and glass of beer. This plaque can be seen outside the Mad Hatter, but although Greene King continues to brew Morlands Original and Old Speckled Hen beers at its Suffolk plant, you won't find them on draught in today's pub.

The contemporary pub – more accurately, a quirky cocktail bar – is a very different proposition. It takes the Alice in Wonderland theme to heart with bar staff dressed up in various costumes, including of course the hatter himself. To enter this particular Wonderland you need to ring a bell and answer a question posed by the guardian, a first for Oxford! Its 'tea parties' include cocktails served in dainty teapots, with low lighting, mood music and live events including jazz and comedy. The Mad Hatter appeals mainly to young customers, who are requested to 'dress appropriately for the tea party' and can book in advance. Whatever would Don Bradman have thought?

Please note: The Mad Hatter has restricted opening times so check in advance. At the time of writing these were Thursday to Saturday evenings only, plus Tuesday Jazz Nights during university terms, but it was available to hire at other times.

Port Mahon, St Clement's Street

It's not unusual for pubs to be named after the site of battles or other military victories, but this one is fairly obscure. The culinary creation that takes its name from the same place is, however, a household name.

The Port Mahon can boast of having the same name for over three hundred years – quite some achievement these days – but the sea battles at Mahon, in the Balearic island of Menorca, have long since faded from the public memory. The first was fought in 1708 as part of the War of Spanish Succession, delivering the island into British hands.

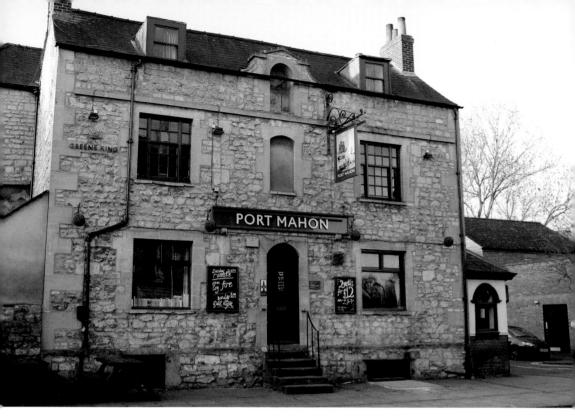

Port Mahon.

The pub was built shortly after this, in 1710, on the site of an orchard. What became known as the Battle of Port Mahon or Battle of Menorca occurred in 1756, when the French dislodged the British and assumed control of the island.

Remarkably, considering this was an ignominious defeat, the pub retained its name. Admiral John Byng brought a fleet of warships from Gibraltar to dislodge French troops that had taken over the island, which was of strategic importance in the Mediterranean. But the British were undermanned, and after a fierce battle they retreated. Byng was court-martialed for not doing enough to defend the British garrison, and executed in 1757 on a ship in Portsmouth harbour. The action against him was very controversial, perhaps explaining why the pub's name remained unchanged. The victorious French commander, the Duke of Richelieu, ordered a mighty banquet to celebrate. One of the chef's creations was a tangy sauce, named after Mahon – now universally known as mayonnaise.

The pub is a substantial, stone-built structure on the main road leading towards London, with thick walls typical of the period and a lower bar added later. You still enter up a short flight of steps, as the area used to flood on a regular basis. It became a Morrell's Brewery pub in 1830 and remained so until the brewery's demise in 1998, and is now owned by Greene King. It is a large, busy pub popular with locals, decorated with a nautical theme.

Part IV

Around Oxford

Here is a selection of pubs well worth making a trip out of the city centre to visit. All are within the Oxford Ring Road, and postcodes are given to help locate them.

General Eliott, Manor Road, South Hinksey, OX1 5AS

Not many pubs have a poem named after them – fewer still one by a world-famous poet, in this case Robert Graves (1895–1985). Best known as a war poet because of his experiences as a serving officer in the First World War, Graves came to Oxford University in October 1919 to read English Language and Literature. His health was so delicate, after wounds received in the Battle of the Somme and a bout of Spanish Flu that he was permitted to live outside the city. He took up residence at Boars Hill, just a mile or so from South Hinksey, and it was then that the poem was written.

The pub is one of several in the UK named after General Augustus Eliott (1717–1790), and his name is often misspelt – an error not being repeated by the pub's new owners. Eliott had a long and distinguished military career, reaching its high point when he was Governor during the Siege of Gibraltar from 1779 to 1783, when he successfully held off the Franco-Spanish forces with up to 100,000 men at their disposal. One of the consequences is that Gibraltar remains British territory, even today.

Eliott might have been a national hero but in the 1920s, as now, many people had no idea who he was. Graves set out to rectify that in a humorous rather than a stern way, imagining that the man depicted on the pub sign comes back to life:

'Oft-times he drinks, they say, and winks
At drunk men lurching home.'

From the tone of the poem one might deduce that Graves revelled in the country simplicity of South Hinksey, after his war experiences. The cock and hen, the loitering men, the 'hayseed world' and 'damsons clustering ripe' must have seemed the image of England that many went to war to protect, and that image can still be enjoyed today. South Hinksey is a picture postcard village yet less than two miles from the city centre, St Laurence church dating from the thirteenth century. Without doubt, the General Eliott is its focal point.

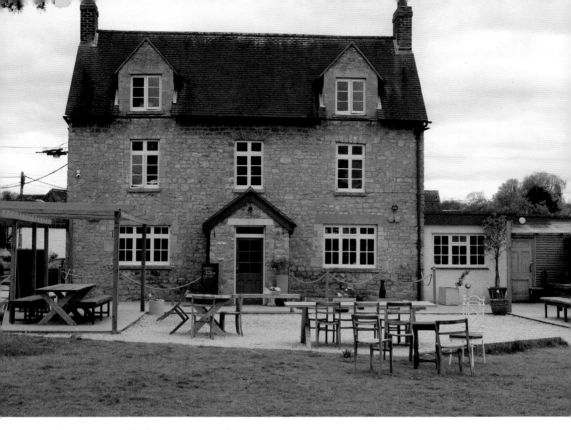

Above: General Eliott, re-opened in 2014.

Below: General Eliott landlady Helen Hazlewood in the philosopher's chair.

Relaxing in a country pub ... on the edge of the city. Oxford CAMRA chairman Tony Goulding and his wife Marie take time out at the General Eliott.

The pub was brought back to life by village couple Cass and Helen Hazlewood at the end of 2014, having been closed and derelict for nearly six years. Villagers fought a long and ultimately successful campaign to resist plans to redevelop the site for housing, and during the years of closure resorted to weekly pub-style meetings in each other's homes. Today the General Eliott is a thriving free house with a growing reputation for cask ales and good, wholesome, locally sourced food ('bistro not gastro'), popular with walkers and appealing to families with a better than average range of children's dishes. A roaring real fire greets visitors in winter, and the great chair beside it once belonged to the Oxford philosopher Richard Hawkins. General Eliott would no doubt approve of how 'his' pub has come back to life, against all the odds.

Isis Farmhouse, by Iffley Lock, OX4 4EL

Here's a curiosity – a pub with no public road access. Although supplies are now delivered by lorry along a private track leading through a nature reserve, the only way for patrons to approach is a path alongside the River Thames, or Isis. If approaching from Iffley village, via the lock, the path is lit. If approaching from the city, a distance of less than two miles, the path is not lit. This access problem might add to the pub's charm, but it does restrict opening hours.

The Thames is unusual in being known by two names, but only around Oxford and upstream towards its source in Gloucestershire. Why it is known as the Isis is open to debate, one theory being that this is a corruption of the Latin name for the river, Tamesis. Several businesses in and around Oxford have Isis in their name, which confuses visitors who now associate Isis with a Middle Eastern terrorist organisation.

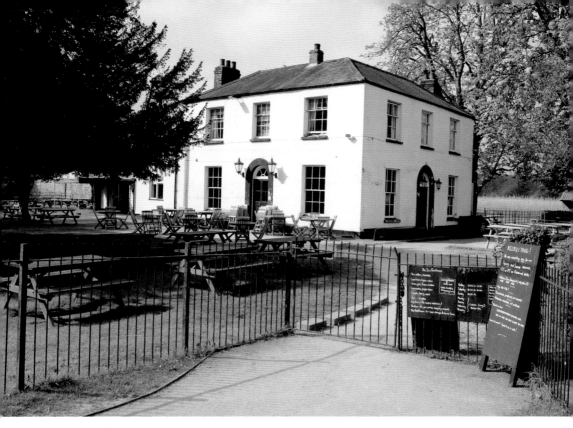

Above: The Isis Tavern.

Below: Supplies to the Isis Tavern used to come down-river.

The Isis Farmhouse, which has also been called the Isis Tavern and Isis Hotel, started life as a collection of farm buildings in the early nineteenth century. When exactly it became a pub is not certain, but this was probably around 1842 and it was owned by Morrell's Brewery for nearly a century and a half from 1855 to 1998. Delivering supplies has always been a challenge, and sometimes these arrived by punt along the river. More usually, Morrell's used a light horse-drawn cart that could navigate the path.

A large meadow called Berry Mead ('berige' was Anglo-Saxon for barley) and nature reserve exists to the rear, and originally this was used to supply fodder to the village of Wootton, to the west of Oxford. An ancient route known as Hay Way took the produce to the village over the meadow and along what is now Old Abingdon Road, and then up Boars Hill. The pub, a nearby cottage and a boathouse are collectively known as Haystacks Corner.

Another curiosity, until the boundary changes of 1974, is that this western side of the river (including Abingdon Road all the way up to Folly Bridge, in the city centre) was in Berkshire rather than Oxfordshire – and there is still a pub on Abingdon Road named the Berkshire for that reason. This had consequences for the Isis Tavern, as the Berkshire coroner held hearings at the pub between 1850 and 1925 to determine the cause of death of bodies found in the water. Bodies found on the Berkshire side of the river produced a reward of 7s 6d for whoever pulled them out; but Oxfordshire paid only 5s. You can guess on which side they were always hauled ashore! A landlord of the pub fell in and drowned while fetching water in 1923, when the pub had no running water.

The river has menaced the pub on many occasions, most notably in 1947 when it was flooded to a depth of 45 cm, with a flood mark still on show in the bar. This caused the landlord and his family to flee upstairs, along with their chickens. Since then it has flooded only once, in December 2013, at a time when floods around Oxford made national news. Various flood marks can also be seen on the lock keeper's house at Iffley Lock, a few hundred yards from the pub. The lock dates from 1632 and was last rebuilt in 1924, when the house was constructed.

One family, the Roses, ran the pub for Morrell's for over half a century from 1927, with Tommy Rose in charge until his death in 1949. On Tommy's sixtieth birthday, Oxford student Lord Douglas Hamilton fired sixty rockets from the pub. His funeral procession went along the river by punt manned by his five sons – he also had five daughters. Bill Rose was landlord from 1949–1977, having previously operated a foot passenger ferry (cost: 1d) across the river at nearby Donnington, before the road bridge was opened in 1962. After the closure of Morrell's in 1998 came a period of decline until the present owner, Jonathan Price, took over in 2008 and it became a free house.

The pub serves a simple selection of hot and cold food, including afternoon teas, home-made cakes, real ales from local breweries served direct from the barrel, and the usual range of drinks. It prides itself on its genuine (not manufactured) rustic charm and environmental credentials, including wood-burning stoves and electricity supplied 100 percent from renewable resources. It also hires out canoes. You can sit in the very large garden overlooking the river watching rowing teams at practice, private and

public boats cruising the Isis, and copious wildlife including geese, swans and ducks that congregate at the nearby lock.

Not surprisingly, most of its custom comes at weekends and during the summer, but it is only open year-round on Fridays, Saturdays, Sundays and Bank Holidays, and also on Thursdays in summer. It is not easy to reach by public transport, but is only a ten-minute walk from Iffley village via the lock.

Mason's Arms, Quarry School Place, Headington, OX3 8LH

If you want to visit a thoroughly traditional British pub which has made only modest concessions to modern times, then a trip to the Mason's at Headington Quarry is highly recommended. It is four times winner of Oxford CAMRA's Pub of the Year award and holder of that title in 2014–15, and also has the distinction of having the only brewery operating within the city boundary, although another one is planned.

The pub is named after the stonemasons who laboured in the quarries around here, supplying much of the stone used to build Oxford's colleges until the eighteenth century. A building thought to be an unlicensed alehouse stood in the garden of the present building, which dates from around 1900, and was constructed by Allsopps Brewery although later taken over by Halls. It is now, proudly, a free house.

So far, so unremarkable, you might say – but what happened to make the pub remarkably unchanged happened over a long period. It has been run by only four families since 1928, when Albert and Rose East took over. Then came William Spencer, and in 1966, Clifford Gurle, who retired in 1996 saying he hoped the pub would not

The Mason's Arms – several times Oxford CAMRA Pub of the Year.

change too much. He needn't have worried, as the Meeson brothers took over in 1997 and remain in charge today, keeping a very traditional pub that doesn't serve food, is open only in the evenings except at weekends, and maintains darts, crib, Aunt Sally and bar billiards teams – the only pub still in the Oxford bar billiards league.

It is a free house serving mainly locals and CAMRA members from near and far, with always a good selection of real ales on offer including some unusual choices. The Headington Beer Festival is held each September in a modern function room at the rear, while in the former outside toilets is a micro-brewery called … the Old Bog. Production is very limited – mainly for the pub's own use – but at the time of writing, Old Bog Beers were being brewed off-site.

Perch, Binsey Lane, Binsey, OX2 0NG

One of Oxford's best-loved riverside pubs returned to business in April 2015 following a major refit under new owners, who also operate two Mamma Mia pizza houses, and the Portobello restaurant, in north Oxford. Proprietor Jon Ellse has pubs in his blood, however, and plans to return some of the pub atmosphere to the Perch despite its strong emphasis on food. His father was Wally Ellse, a real Oxford character and long-term landlord of the Turf Tavern, who previously ran White's Bar on the High Street which closed in the 1970s. Members of the Ellse family also ran the Westgate pub, and the Victoria on Walton Street.

The Perch is a picturesque, partly thatched building, but this has been the cause of some major problems. Serious fires closed it down twice, in 1977 and 2007, with the 1977 conflagration being particularly serious with fifty firemen in attendance. George Chitty, renowned as the 'rudest landlord in Oxford', ran the pub around that time. But the open fires, flagstone floors and thick stone walls survived, the walls dating from the seventeenth century when the pub was constructed. It is reputed to be haunted, by a military man who drowned himself in the river.

Cottages in this area were used by pilgrims in medieval times heading for a holy well, which can still be seen in St Margaret's churchyard, about a mile from the pub (head past the cottages directly opposite the entrance). The well reputedly had healing properties, but looks rather murky now. Henry VIII was thought to have visited, and Lewis Carroll refers to the well in *Alice's Adventures in Wonderland*.

As Binsey village – owned entirely by Christ Church College – has only about a dozen houses, the Perch has always been a destination pub. You can only reach it by driving a mile and a half down a narrow lane leading off Botley Road, or on foot alongside the Thames/Isis. For that reason expectations tend to be high, and the reborn pub aims to fulfil them with an English farmhouse menu featuring dishes such as pies, stews and roasted ox cheeks. Jon Ellse believes the pub has never realised its potential, having operated as a French gastro-pub before, and he has invested in a new kitchen able to serve seventy-five guests inside and literally hundreds more in the extensive garden, which has its own Shed Bar serving beer and burgers in summer. The Perch's goal is to be 'completely unpretentious'.

You can't actually see the river from the gardens, as a path leads from the waterside and the garden has numerous trees including three ancient weeping willows. But this

The revamped Perch opened in April 2015.

doesn't detract from the pleasure of visiting the Perch, a free house where drinkers are also welcome and which serves home-made snacks such as giant scotch eggs. The bar has been re-established in the central position it occupied before, dispensing three real ales and one real cider.

There is no public transport to Binsey, but it can be incorporated into a riverside walk including the Trout (another twenty-thirty minutes upstream). You can walk there from Oxford via the pubs of Jericho, before crossing Port Meadow to the riverside path.

Plough Inn, Wolvercote Green, Wolvercote OX2 8BE

A listed building dating from around 1832, the Plough is a very pleasant country-style pub with outside tables on the edge of Oxford. It is close to the ancient open space of Port Meadow, which can be seen just beyond the canal and railway which run alongside the green. Both modes of transport have played a part in the pub's history, as it was once frequented by bargemen who had a reputation for drunkenness and brawling, and whose swear words used to be repeated by a parrot resident in the bar long ago.

A sombre event occurred on Christmas Eve, 1874, when an over-crowded holiday train from London Paddington to Birkenhead came off the rails a couple of miles away at Shipton-on-Cherwell. A very old carriage had been added at Oxford and a wheel on this had fractured, causing two of the fifteen carriages to tumble down an embankment with the loss of thirty-four lives. The dead were transported to the Plough and laid out

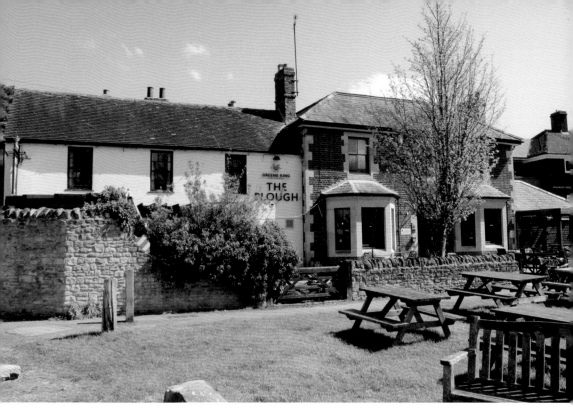

The Plough, on Wolvercote Green.

in what was then the stables and is now the dining room, as Oxford's mortuary was closed for Christmas. Even today, curious tourists who know this story (often from across the Atlantic) enquire about ghosts and if any bodies are buried here. Of course, they are not!

Landlord Tim Bowring, who will celebrate twenty years at the pub in 2016, takes this in his stride and has happier tales to tell, as the lounge at the rear and extended part of the Plough has about 750 books in what is known as The Library – certainly not the 'book wallpaper' favoured by some pubs. The bar is the oldest part and this has stone-flagged floors, and here you will find the copy of a Retail Beer and Cider licence granted to landlord Thomas Beckinsale in 1872. Also on display is a list of beer prices provided by Morrell's in 1964, when a pint of Light or Dark cost 1s 3d, Bitter 1s 6d, Varsity Bitter 1s 9d and College Ale 3s. Wholesale prices for a barrel are pencilled in alongside, leading Tim to conclude that the profit on selling beer was far greater then, as pubs today make their mark-up on spirits, soft drinks and food.

The Plough has some tables out on Wolvercote Green, where special events are held in summer.

The One, Botley Road, OX2 0AB

This is now a successful Asian fusion restaurant in what used to be the lounge bar, but still a traditional pub in the public bar. It specialises in cocktails and has a large rear garden with huts for shelter and smoking, so can be busy throughout the day.

The name might be unfamiliar, as new owners took over in 2012 after a period of closure. From 1997 to 2012 it was called the White House, but many people still remember the pub by its long established name, the Old Gatehouse. The One is a far cry from the 1950s, when landlady Mrs Cox served bar snacks and was prepared to cook meals for customers if they specifically wanted one, a rarity in those days. Her husband specialised in bending metal beer bottle tops double between his thumb and forefinger, and presumably could sort out any trouble on the premises. In the 1950s, with the railway station and a large engine shed nearby, railwaymen formed the basis of the pub's custom.

There may have been a pub or farm on this site in medieval times, when it was close to the gates of Osney Abbey. A toll house stood near this spot in the eighteenth century, to extract money (legally!) from people riding along the Botley Turnpike Road towards Witney. This road became known as Seven Bridges Road before reverting to Botley, a suburb in the west of Oxford. The toll house and gate were removed in 1852 after opening of the railway station, and it is from this that the pub took its original name. The old pub sign showed a masked highwayman vaulting over the gate on horseback, while the gate keeper shakes his fist in impotent rage.

The present building dates from 1850 and acted as the new toll house until becoming a pub in 1868, with the toll house moving further along Botley Road until tolls were abolished by Parliamentary decree in 1880. The pub sign showing a highwayman tapped into an ages-old fear of brigands, as Botley Road was so notorious for robbers

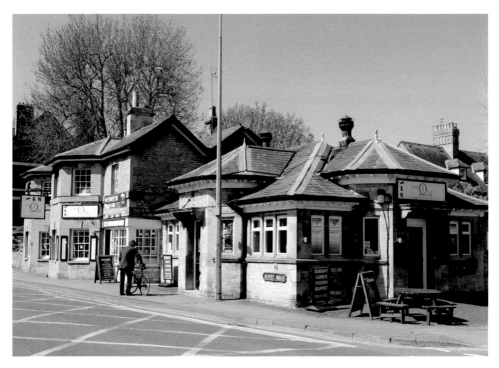

Bar and Asian fusion restaurant The One.

The highwayman vaults the tollgate when The One was the Old Gatehouse (*Photo Courtesy of Oxford Mail/The Oxford Times*).

that in 1776, a group of vigilantes was set up to combat them. Today it is one of the main arterial routes into the city.

Becoming the White House was symptomatic of the times as pubs struggled to create a new identity – a trend that continues. There is now a pub called the White House on Abingdon Road, which dates from 1898 and reverted to this name a few years ago having been known as the Folly Bridge Inn for nearly twenty years. The name game continues …

The One was established by a family who also run the Paddyfield restaurant in Oxford, and it aims to make the dining experience fun with a prancing dragon used in New Year celebrations, and a mainly Asian menu plus English dishes with an exotic twist. But beware, after a few drinks, of taking up The One Challenge. This involves eating eight spicy Szechuan chicken wings, clean to the bone, in fifteen minutes. If you succeed you win a four-pint jug of beer, but the restaurant 'reserves the right to rub chilli in your eyes during the challenge!' A suitable punishment for highwaymen, perhaps.

Trout, Godstow Road, Wolvercote, OX2 8PN

A scenic retreat for nearly four hundred years, this pub was a particular favourite of Inspector Morse and appears in four episodes – more than any other. It is situated on a narrow road about three miles from the city centre, and can be reached by a long but pleasant walk along the Thames/Isis, or by Number 6 bus to Wolvercote then a ten-minute walk.

The Trout does not stand directly on the river but on a stream beside a weir, yet is only a couple of hundred yards from the Thames Path (look to your right when approaching from Oxford, just after Godstow Lock). Just by the lock are the ruins of Godstow Nunnery, where Henry II (1154–1189) is said to have dallied with his lover Fair Rosamund, and a guest-house for the nunnery may have stood where the pub is now. It then became a fisherman's house and an inn by 1625, with the present structure thought to date from 1737.

It is a substantial two-storey stone building with a long single-storey extension, and a large waterside terrace which is very popular on warm days for drinking or dining. A footbridge leads over the water to Trout Island, but safety concerns mean this is not open to the public. A flock of peacocks used to wander the grounds, but at the time of writing only one bird remained.

In the old part of the building are low beams, stone flagged floors and ancient fireplaces, contrasting with a glass-fronted cool room for wines. Also here are sketches and hand-written poems which appear to date from the 1920s, including one which laments:

If I should forget thee, righteous Trout, may all my timbers shiver
A port of call to shout about, the best on all the river

The Trout is laid out mostly as a dining pub which can accommodate over one hundred people, and makes the most of its Morse connections with the front covers of a dozen of Colin Dexter's novels, on which the TV series was based, framed on the wall. But the area had literary connections long before this: both Lewis Carroll, in *Alice's Adventures in Wonderland*; and Matthew Arnold, in *The Scholar Gypsy*, mention Godstow. *The Wolvercote Tongue* is the first Morse episode to feature the Trout, as Morse and Lewis stand on Godstow Bridge looking at the floodlit pub. It also appears in *Who Killed Harry Field?* when Morse takes Helen Field for a drink here.

The various breweries and other companies that have owned the Trout over the years appreciated its potential. Charrington acquired it in 1961 and its director Mr R. F. Beer (!) re-opened it in 1962 with a promise not to destroy its character. An *Oxford Mail* report in 1963 warned, 'If you crave tranquility, avoid it at weekends ... It is full of the youngest, brightest crowd of Oxford undergraduates and their girl-friends' – no mention of female undergraduates, at that time!

It suffered a serious fire in 1961, and during restoration a visitors' book was found from the 1920s signed by Edward, Prince of Wales; King Hussein of Jordan; and Evelyn Waugh. Regulars protested in 1996 about plans by Bass to serve 'pub grub', when it

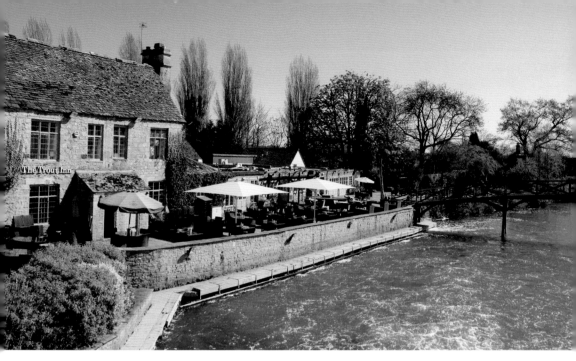

Above: The Trout Inn is beside a weir.

Below: The stream beside the Trout Inn froze solid in 1933 – at Christmas, judging from the character second on the left.

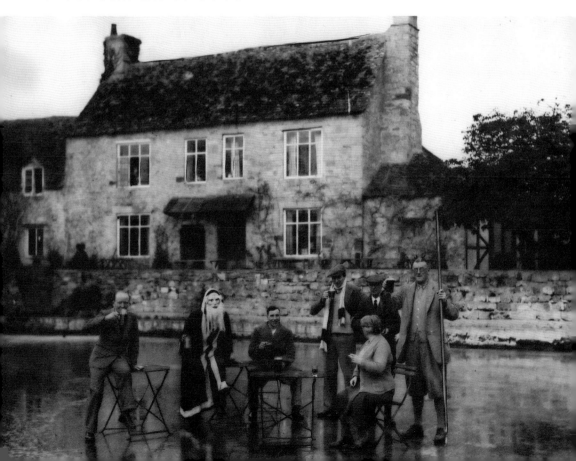

was about to become a 'Fork & Pitcher' restaurant. A £1.3 million renovation in 2001 created the elegant dining pub of today. The *Oxford Mail's* advice of 1963 holds true, and not just at weekends – come outside busy times if you can.

Victoria Arms, Mill Lane, Old Marston, OX3 0PY

This is not only one of the most picturesquely located pubs in Oxford, but one of the most interesting for fans of the *Inspector Morse* TV series and people who want to know more about the Civil War in and around the city. It is on the eastern bank of the shallow River Cherwell, and it is still possible to hire a punt in the city centre and come here by river. But you are more likely to arrive by road, or along a riverside path that leads northwards out of University Parks.

A room in the oldest part (on the left hand side if you stand with your back to the river) is dedicated to Oliver Cromwell, leader of the Parliamentarians, with the fairly bold claim, 'In 1646 Cromwell sat here waiting to liberate the city'. There's no firm evidence of this, but a cottage rather than a pub stood here at that time. Oxford was

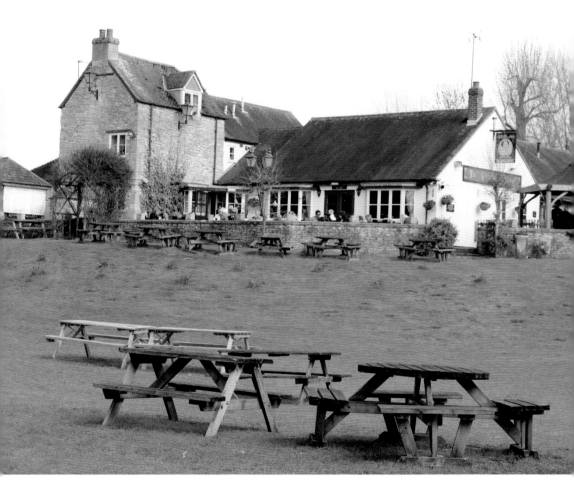

Riverside garden at the Victoria Arms, Old Marston.

Above: A photograph on the wall at the Victoria Arms shows *Inspector Morse* actor
John Thaw filming there.

Below: The Victoria Arms in the snow, circa 1908.

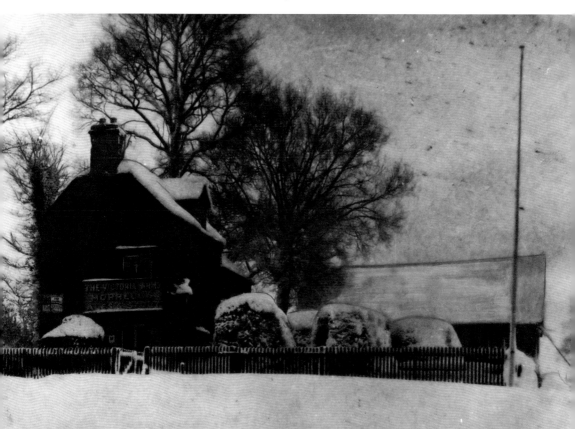

the seat of King Charles I from 1642–1646, and in Old Marston village a few minutes' walk from the pub is Cromwell's House, marked by a blue plaque commemorating the place where the Royalist surrender of Oxford was negotiated between May and June 1646.

The stone cottage, which forms the oldest part of the pub today, stood on the site from the seventeenth century and became a pub by 1871 when it was known as the Ferry Inn. A passenger ferry operated here for hundreds of years, right up to 1971, when it was made redundant by construction of Marston Ferry Road linking the eastern side of the city with Summertown in north Oxford. A path used to lead from Summertown to the ferry, which was latterly a punt attached to a rope stretching across the water. The ferryman was also the pub's landlord, who came down to the riverside when a prospective passenger rang a bell.

In 1900 it was acquired by Victor Biovois who renamed it the Victoria Arms, commemorating the Queen, who was nearing the end of her reign. By 1958 the pub was closed and derelict, but it was purchased in 1959 by the Oxford Preservation Trust when it was extended, only for the extension to be damaged by fire in 1964. It was then rebuilt, and later greatly extended, and is today one of the most popular dining pubs in Oxford under the stewardship of Wiltshire brewery Wadworth. David and Ruth Kyffin were landlords for many years, and as they kept sheep in a nearby field, they refused to have lamb on the menu.

The 'Vicky', as it is known, has a plaque above the bar erected by the Preservation Trust, which reads, 'Near this spot Inspector Morse recited *The Remorseful Day* to Sergeant Lewis in the episode of that name. This plaque was unveiled by Colin Dexter OBE on 5 April 2013.'

Dexter is author of the Inspector Morse novels on which the TV series was based, and *The Remorseful Day* is the final episode in the series when Morse dies of a heart attack. Morse and Lewis discuss their final case together at the pub, when Morse quotes a poem by A. E. Housman (1859–1936) which is actually called 'May' and includes the lines:

> How hopeless under ground
> Falls the remorseful day

The Victoria Arms does in fact appear in three episodes of the series. In *Who Killed Harry Field?* while on the pub's riverside lawn, Morse agrees to back Lewis's bid to become an inspector. In *The Daughters of Cain*, Morse and Kay Bach have a drink before a punting trip. Pictures of John Thaw filming at the pub appear on the walls. It is a great place to visit at any time of year but especially on a summer's day, when you can enjoy a drink or meal on the extensive riverside lawn.

White Hart, St Andrew's Road, Headington, OX3 9DL

If you take Old High Street in the Oxford suburb of Headington and walk away from the busy shopping area along London Road, you soon start to feel you are in a village rather than a suburb. Headington was indeed a village until the nineteenth century,

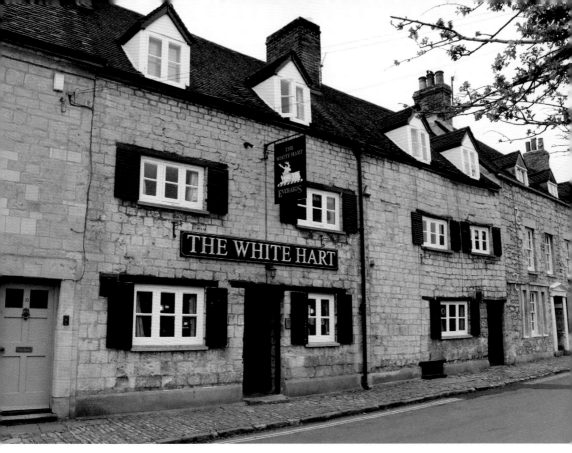

The White Hart, Headington – home of the notorious Joan.

and St Andrew's Church opposite the pub has a chapel dating from the thirteenth century and an arch which is even older. Being only a couple of miles from Oxford, Headington used to attract students and other city dwellers to enjoy the country air and some less innocent pursuits.

And so we come to Joan of Headington, an innkeeper who owned the pub that was to become the White Hart in the eighteenth century. Parts of the pub date from the fifteenth century, when a tunnel led from the church opposite to shelter priests who kept the Roman Catholic faith. The stables by what is now the pub's rear entrance, which are used as outbuildings at the end of the long garden, could accommodate up to six horses. A stone mounting block can still be seen.

Joan of Headington is mentioned several times by the seventeenth century diarist Anthony Wood, and she was so notorious that she appears in a humorous poem and a play. Whether she deserved such infamy is open to question, but there is little doubt that the pub, as was not uncommon, also functioned as a brothel. Wood, whose diaries are a great source for Oxford historians, mentions stopping at Joan of Headington's alehouse several times (we know not why), and on a visit in 1690 he notes that Joan refused to take in an illegitimate child. According to the Oxford History website, six Joans were buried at St Andrew's between 1684 and 1719, one of whom is probably this colourful character.

The satirical poem mentioning Joan was published in 1691 entitled 'Academia: The Humours of the University of Oxford, in Burlesque Verse', by Alicia D'Anvers. It includes the lines:

> And so that very Night he runs
> To honest Joan of Hed----tons
> Who brags she has been a Beginner
> With many an after-harden'd Sinner ...
> Not, that they're given all to whoreing
> Some are for honest downright roaring

The short play is called *The Tragi-Comedy of Joan of Hedington* by Dr William King of Christ Church College, Oxford, and published in 1712 'in imitation of Shakespear' (sic), as part of his book *Useful Miscellanies*. In a new edition produced by local historian Stephanie Jenkins in 2002, Joan is described in the cast list as 'of a calling which though dishonourable, yet has been made use of in all ages ... at least she despises the more vile practices of others in the same profession'! In the opening scene, a rival innkeeper called Mother Shephard describes Joan as a 'naughty woman' and 'disgrace to the town', and complains that gentlemen did not come to Mother Shephard's alehouse in case people thought they were going to Joan's. It ends with a customer attempting to hang Joan, but she is cut down by her husband. Then, as now, the story was good fun – but an archaic script in the rear of the pub is about Headington generally, rather than Joan.

The pub gained its present name – a white hart was the emblem of Richard II – around the middle of the eighteenth century. It hosted the South Oxfordshire hunt, which met outside, and was also known for cockfighting. The oldest part of the pub is at the front, and it is currently owned by Leicestershire brewer Everards with a focus on real ales and home-cooked pies.

Everards' only other property in Oxford, the Black Boy, is just a few hundred yards away and run as a gastro-pub – visitors fearing the name is not politically correct will note that the pub sign, inlaid in stone, is of a black horse rather than a human being. The pubs of Headington are celebrated in a saying collected by Stephanie Jenkins, dating from the nineteenth century:

> A Black Boy rode a White Horse and carried a Royal Standard shouting Rule Britannia. He was chasing a White Hart which had a Bell around its neck. This disturbed The Fox, which ran aground in the Prince's Castle.

The Black Boy, White Horse, Royal Standard, Britannia and White Hart are still with us; the Bell, Fox and Prince's Castle, not so.